PORTALS

The Visionary Architecture
of Paul Goesch

PORTALS

The Visionary Architecture
of Paul Goesch

Robert Wiesenberger and Raphael Koenig

Clark Art Institute
Williamstown, Massachusetts

Distributed by Yale University Press, New Haven and London

Published on the occasion of the exhibition *Portals: The Visionary Architecture of Paul Goesch* presented at the Clark Art Institute from March 18 to June 11, 2023.

Portals: The Visionary Architecture of Paul Goesch is organized by the Clark Art Institute and curated by Robert Wiesenberger, curator of contemporary projects. It is based on the Paul Goesch collection at the Centre Canadien d'Architecture/ Canadian Centre for Architecture, Montreal.

This exhibition is made possible by Katherine and Frank Martucci.

Produced by the Publications Department of the Clark Art Institute, 225 South Street, Williamstown, Massachusetts 01267

Anne Roecklein, *managing editor*
Kevin Bicknell, *editor*
Annie Jun, *assistant editor*
David Murphy, *rights and image use editor*
Eliza Dermott, *publications intern*
Greer Ingoe Gerney, *publications intern*

Copyedited and proofread by Kara Pickman, Pickman Editorial
Design and layout by David Edge
Printed by Puritan Press
Distributed by Yale University Press,
302 Temple Street, P.O. 902040,
New Haven, Connecticut 06520-9040
yalebooks.com/art

Printed and bound in the United States
10 9 8 7 6 5 4 3 2 1

Cataloging-in-Publication Data is available from the Library of Congress.
Library of Congress Control Number: 2023901407

978-1-935998-57-0 (Clark Art Institute)
978-0-300-26969-7 (Yale University Press)

Photography credits: Fig. 2: Otto Rietmann; Fig. 3: © Mongi Taleb, Cologne; Fig. 6: ©2023 Artist Rights Society (ARS), New York/VG Bild-Kunst, Bonn; Fig. 9: Paul Wolff; Fig. 11: Kai-Annett Becker; Fig. 12: Kai-Annett Becker

Front cover: Paul Goesch (German, 1885–1940), *Architectural composition (Triumphal arch)* or *Visionary design for a gateway*, c. 1920–21. Graphite and gouache on watercolor paper, 9 1/2 x 12 5/8 in. (24.2 x 32 cm). Centre Canadien d'Architecture/Canadian Centre for Architecture, Montreal, DR1988:0241.
Back cover: Paul Goesch (German, 1885–1940), *Architectural fantasy* (detail), c. 1920–21. Carbon copy, 12 15/16 x 8 5/16 in. (32.9 x 21.1 cm). Centre Canadien d'Architecture/Canadian Centre for Architecture, Montreal, DR1988:0144.

PORTALS

The Visionary Architecture of Paul Goesch

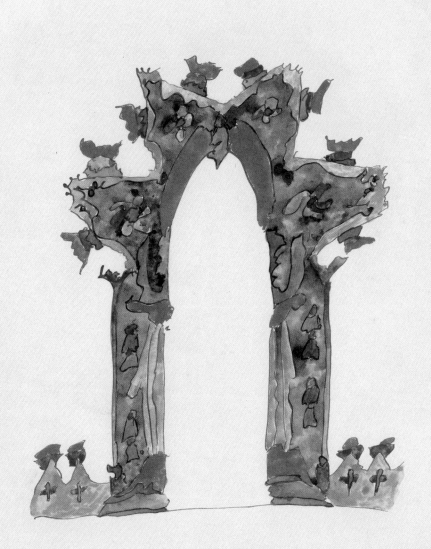

Director's Foreword

It is with great pleasure that the Clark Art Institute introduces new audiences to the technicolor worlds of Paul Goesch, an important but understudied member of the historical avant-garde. *Portals: The Visionary Architecture of Paul Goesch* is the first exhibition dedicated to Goesch's work in North America and the first to focus on his architectural fantasies in particular; this book is, likewise, the first in English to treat the drawings of this remarkable artist and architect who made them almost exactly a century ago.

This exhibition would not have been possible without the kind cooperation of the Centre Canadien d'Architecture/Canadian Centre for Architecture (CCA), Montreal, our neighbors just a few hours to the north. The CCA is an extraordinary institution and, in many ways, a kindred spirit for us at the Clark, given their commitment to both collecting and advanced research and inquiry. We owe our deepest thanks to Clark Trustee Frank Martucci, and his wife, Katherine, longtime friends of the Clark whose generosity and vision have helped us realize this exhibition. We also express our gratitude to Timur Galen and Linda Genereux for their meaningful support of this project. Thank you to our colleagues down the road at the Williams College Museum of Art for their generous loan of German expressionist prints, which allow us to contextualize Goesch's work along with selected objects from our own collection.

Paul Goesch's story is a tragic one but there is also an irrepressible energy, inventiveness, and sense of play in his drawings that appeals to audiences of all kinds. Perhaps, too, there is some poetry in his exhibition appearing in the Clark's Manton Research Center, which celebrates its 50th anniversary this year. The Manton building, with its massive, granite-clad volumes, could not be further from Goesch's intimate and fanciful designs, which almost appear to float off the page. And yet the Manton building was designed by Pietro Belluschi, of the Architects Collaborative (TAC), an office founded by Walter Gropius, who left Germany shortly after the Nazis came to power. Gropius was a colleague of Goesch's, and just two years his senior: both were members of the radical Work Council for Art and the Glass Chain correspondence group in the early 1920s. One wonders about Goesch's trajectory had he also lived another three decades and received the necessary treatment and care.

In addition to the superb team at the Clark that made this show a reality, I would like to thank exhibition curator Robert Wiesenberger and catalogue contributor Raphael Koenig for bringing this energizing work to the Clark and giving it the attention and context it deserves.

Olivier Meslay
Hardymon Director

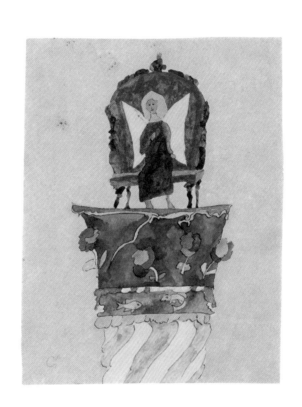

Acknowledgements

This project would not have been possible without the hard work of the Clark's outstanding staff. In particular, I would like to thank the exhibitions team of Nathan Ahern, Julie Blake, Paul Dion, Tom Merrill, Kathy Morris, and Jessica Pochesci; Annie Jun, David Murphy, and Anne Roecklein in publications; designer David Edge; Daphne Birdsey and April Clay in advancement; Will Schmenner in programs; Terri Boccia and Karen Bucky in the library; Carolynn McCormack and Vicki Saltzman in communications; and Anne Leonard, Manton Curator of Prints, Drawings, and Photographs. Many thanks to Robert and Martha Berman Lipp Chief Curator and deputy director Esther Bell, and to Hardymon Director Olivier Meslay, for believing in this project. For their research assistance and insights, I am especially grateful to Williams College student interns Sarah Chapin ('23) and Ella Comberg (M.A. '24).

Deep gratitude goes to our colleagues at the Canadian Centre for Architecture, Montreal, for making their extraordinary collections available to us, in particular Giovanna Borasi and Martien de Vletter; Shira Atkinson, Tim Klähn, and Gwen Mayhew on the reference team; and Genevieve Boilly, Catherine Lariviere, Christine Lefrancq, and Kyla Smith in collections management. Thanks to our friends at the Williams College Museum of Art, in particular Lisa Dorin, Elizabeth Gallerani, Kevin Murphy, and Pamela Franks, for generously lending artwork from their collection.

For his kind support and research assistance on this project, I am grateful to Goesch family relative Stephan Foerder in Berlin. For their expertise on Paul Goesch and assistance in reviewing elements of this publication, I would like to thank Stefanie Poley, of the Freundeskreis Paul Goesch in Cologne, and Thomas Röske, of the Sammlung Prinzhorn in Heidelberg. Indeed, this project benefitted enormously from the scholarship developed under the auspices of the two largest repositories of Goesch's work in Europe, the Sammlung Prinzhorn and the Berlinische Galerie in Berlin, as well as Stefanie Poley's tireless efforts on behalf of Goesch's legacy. I would also like to thank mentors who have championed this project or laid the groundwork for it through their teaching, in particular Barry Bergdoll, Jean-Louis Cohen, Michael Conforti, Noam Elcott, Kenneth Frampton, Reinhold Martin, Mary McLeod, and Felicity Scott.

Finally, I would like to thank Raphael Koenig for his contribution to this volume and to the project itself. Raphael and I first encountered and were electrified by Goesch's work together at the same time. We have been discussing it since then and this project is the result of those conversations. My understanding of and sensitivity toward the nuances of art and mental health I credit to his scholarship and generosity of spirit.

Robert Wiesenberger
Curator of contemporary projects

Passages:
The Work of Paul Goesch

Robert Wiesenberger

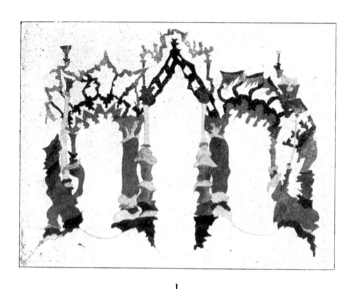

I

Kohlenmangel, daher Backsteinmangel — Zementmangel — Glas-
mangel. Mangel das Einzige, das im Überfluß vorhanden ist. Aber
auch Glaube an die Zukunft ist noch da, wenngleich weniger reichlich.
Ein gut Teil des Vorhandenen steckt hier in diesen Blättern.

Von den Entwürfen dürfte niemand unter uns die Verwirklichung
eines einzigen erleben. Also sind es Luftschlösser, Utopien, Phan-
tastereien, überflüssige Spielerei? Man kann es immer wieder hören
und lesen: „Nur die Arbeit für Kleinhäuser, für Siedelungen, nur die
entsagungsvolle Tätigkeit für das Kleinste und Einfachste habe heute
noch Wert. Runter von den Wolken, Ihr Phantasten. Stellt Euch
auf die Erde. Eure blühende Formenwelt ist ja ein Hohn auf diese
Zeit." (Als ob diese Zeit nicht zum Hohn herausforderte.)

Aber die Kritiker haben Unrecht. Keiner verachtet das Kleine
und Einfache. Niemand unterschätzt Einfamilienhaus und Kaninchen-
stall. Aber es soll nicht der alte Trott fortgesetzt werden — auch
nicht in diesen Dingen. Gerade weil wir ordentlich machen wollen,
was wir in die Hand nehmen, lehnen wir es ab, die Not der Zeit
mit Ersatzmittelchen nicht zu lindern, sondern zu verkleistern,

Fig. 1. Opening page of Adolf Behne's essay in Arbeiterrat für Kunst, *Ruf zum Bauen*, ed. Adolf Behne (Berlin: Verlag Ernst Wasmuth, 1920), 3.

"Lack of coal, therefore lack of bricks—lack of cement—lack of glass. Lack as the only thing in abundance. But there is also still faith in the future, albeit less plentiful. A good portion of what is available in that regard can be found in these pages." —Adolf Behne[1]

So begins *Ruf zum Bauen* (*Call to Build*), a 1920 manifesto and exhibition catalogue by the Arbeitsrat für Kunst (Work Council for Art), the self-declared radical group of artists and architects that had formed amid the ruins of the First World War and the revolutionary ferment that birthed the Weimar Republic. Dedicated to the principle that "Art shall no longer be the enjoyment of the few but the life and happiness of the masses," council members—most of them painters and sculptors—agitated for "the alliance of the arts under the wing of a great architecture."[2] A young architect named Bruno Taut listed their demands, including public funding for experimental architecture and workers' housing; the dissolution of the art academies; and the "destruction of artistically valueless monuments," which, he noted, would free up construction materials.[3] For the German avant-garde of a century ago, rebuilding after catastrophe was a simultaneously physical and cultural task: "The direct carrier of the spiritual forces, molder of the sensibilities of the general public," Taut declared, "is architecture."[4]

Behne's *Call to Build* was crowned by a striking image (fig. 1). Visitors to the group's exhibition would have recognized this small drawing as the work of Paul Goesch (1885–1940; pp. 44–45). Inscribed with the letter G and the title "Sketch for a triumphal gate," the skeletal structure appears to be built from some miraculous, unspecified material in a riot of colors. A pointed arch is flanked by two smaller, rounded ones, all raised on cairn-like columns or colonettes and topped by jagged ornament, as if Gothic tracery were struck by lightning. At once medieval and futuristic, ecclesiastical and eclectic, celebratory and vaguely sinister, Goesch's unbuildable gate seems an odd choice to illustrate such a manifesto, given its titular call. And yet Behne—a critic and art historian, council co-chair and committed socialist—was not blind to the urgent housing shortage or practical needs of the time. Rather, what he was arguing for was above all imagination, so that new building would not reproduce the failed old order. And in this respect, Goesch had a great deal to offer.

1. Arbeiterrat [sic.] für Kunst, *Ruf zum Bauen*, ed. Adolf Behne (Berlin: Verlag Ernst Wasmuth, 1920), 3. Translation by the author. This publication accompanied the group's *Neues Bauen* (*New Building*) exhibition at the prestigious J.B. Neumann gallery in Berlin that year. The use of "Arbeiterrat" (workers council) appears limited to the cover of this publication and may be understood as a typo; the group otherwise used "Arbeitsrat" (work council), including elsewhere in the above publication.
2. Work Council for Art, "Under the Wing of a Great Architecture," in Ulrich Conrads, ed., *Programs and Manifestoes on 20th-Century Architecture*, trans. Michael Bullock (Cambridge, MA: MIT Press, 1971), 44. In the original German: Ulrich Conrads, ed., *Programme und Manifeste zur Architektur des 20.*

Jahrhunderts, Bauwelt Fundamente 1 (Berlin: Ullstein, 1964), 41. The council included artists such as Lyonel Feininger, Erich Heckel, Georg Kolbe, Gerhard Marcks, Emil Nolde, Max Pechstein, and Karl Schmidt-Rottluff. If Expressionism in Germany dates to the founding of the artist group *Die Brücke* (The Bridge), in 1905, then the Expressionism discussed here is of a "second generation." See Stephanie Barron, ed., *German Expressionism 1915–1925: The Second Generation* (Los Angeles: Los Angeles County Museum of Art; Munich: Prestel, 1988).
3. Work Council for Art, "Under the Wing," 44–45.
4. Bruno Taut, "A Programme for Architecture," in Conrads, *Programs and Manifestoes*, 41. See also Conrads, *Programme*, 38.

Among his peers in the Work Council exhibition—some of whom went on to illustrious careers in the modernist boom years of the mid-1920s—Goesch stands out for his formal inventiveness and range, his kaleidoscopic color sense, and his playful and pluralistic embrace of architectural history. He also struggled throughout his life with schizophrenia, a condition for which he was institutionalized, and ultimately murdered by the Nazis. That Goesch was in creative community with the most progressive designers of his day was made possible by a confluence of circumstances: In the early postwar years, when the "lacks" Behne lists in the epigraph—of materials, but also of a stable currency and financing—made any kind of building difficult, the collaborative, compromise-prone, and physics-bound work of architecture lived only on paper as "visionary" emanations of the mind.[5] And in a time when German Expressionists privileged intuition, feeling, and formal experimentation, Goesch was an exemplary Expressionist.[6] Increasingly connected avant-garde media networks also allowed him to correspond, exhibit, and publish, even while institutionalized. These conditions, however, lasted only briefly.

More than two thousand drawings survive Goesch. These include religious, mythological, and folk-loric scenes; portraiture and landscapes; architectural fantasies and fully abstract compositions.[7] Among the architectural drawings, the typology of the portal and archway predominates, and provides the structuring metaphor for this exhibition. The portal here represents both the metaphysical passages of Goesch the spiritualist, steeped in Christian theology and occultism, as well as the altered states of schizophrenia and the so-called doors of perception, in Aldous Huxley's memorable phrase.[8] The portal also evokes Goesch's liminal status between art and architecture, "sanity" and "madness," the architecturally trained insider and the institutionalized "outsider." These categorial confusions and biases have plagued his reception and—as Raphael Koenig explains in this catalogue—contributed to his erasure from history. The present essay aims to characterize Goesch's architectural practice, contextualize it in its cultural moment, and suggest some reasons for its enduring significance. Even among architectural historians, Goesch's name is not well known today. This exhibition and publication, the first dedicated to him in North America and in English, respectively, aim to change that.

5. The term "visionary" includes a range of connotations, from radical architects whose works live only on paper to neurodivergent artists who experience hallucinations or delusions. While broad, the term usefully merges the latter two categories in this case.
6. See Herwig Guratzsch and Thomas Röske, eds., *Expressionismus und Wahnsinn* (Munich: Prestel, 2003).
7. Goesch's work is held primarily by three institutions: the Berlinische Galerie in Berlin, the Sammlung Prinzhorn in Heidelberg, and the Canadian Centre for Architecture in Montreal. The holdings of the last of these, which comprise this exhibition, are overwhelmingly architectural in subject matter.
8. Aldous Huxley, *The Doors of Perception* (New York: Harper & Row, 1954). For the multifaceted metaphor of the portal in this context, and the reference to Huxley, I am grateful to Raphael Koenig.
9. For the biographical details in this section, I am indebted to the chronologies of the three most recent publications on Goesch as well as

the advice of Stefanie Poley, of the Freundeskreis Paul Goesch in Cologne. See Patricia Feise-Mahnkopp and Thomas Röske, eds., *"Von zweifellos künstlerischem Wert": Paul Goeschs Beitrag zur ästhetischen Moderne* (Heidelberg: Sammlung Prinzhorn; Berlin: Kerber Verlag, 2019); Thomas Röske and Prinzhorn-Sammlung der Psychiatrischen Universitätsklinik Heidelberg, eds., *Paul Goesch, 1885–1940: Zwischen Avantgarde und Anstalt* (Heidelberg: Wunderhorn, 2016); Annelie Lütgens, ed., *Visionäre der Moderne: Paul Scheerbart, Bruno Taut, Paul Goesch/Modern Visionaries: Paul Scheerbart, Bruno Taut, Paul Goesch* (Berlin: Berlinische Galerie; Zurich: Scheidegger & Spiess, 2016).
10. Paul Goesch, "'Vita' 10.08.03," Goesch-Paul 12, Paul-Goesch-Archiv, Baukunstarchiv, Akademie der Künste, Berlin.
11. Stefanie Poley, "Paul Goesch: Sein Leben," Freundeskreis Paul Goesch e.v., http://www.freundeskreis-paul-goesch.de/_leben.html. Translation by the author.

Fig. 2. The first Goetheanum by Rudolf Steiner, c. 1921–22. Rudolf Steiner Archive, Dornach, Switzerland.

SPLENDOR AND RETREAT

Born into an educated, well-to-do household in the northern German city of Schwerin, Goesch moved with his family to Berlin at age two.[9] Though baptized Lutheran, he "became fervently Catholic" in his teens: "I was overwhelmed by the stunning splendor of the church," Goesch recalls in a rare autobiographical account, registering an early experience of the power of architecture.[10] He performed poorly in school and suffered from periodic illness. Isolated from his classmates, Goesch writes: "I retreated more and more into myself." Still, tutored by an older student, he developed a love of art, literature, and architecture, from ancient Greece to the German Romantics.

Goesch went on to study architecture, starting in 1903, in Munich, Karlsruhe, Dresden, and Berlin. Six years later, in a session with the pioneering Austrian psychoanalyst Otto Gross, he experienced his first breakdown and entered a sanatorium for treatment. Returning to Berlin a year after that, Goesch received a diploma in 1911 as a state construction foreman, a position in which he seems only to have worked for a few months. Goesch's education was to a large extent extracurricular: Stefanie Poley has emphasized his far-reaching drive "to gain individual insights through personal experience" and through "experiments on his own body and soul."[11] This impulse, which had led him to Freudian psychoanalysis, also sparked his interest in theosophy and the esoteric teachings

15

of Rudolf Steiner, with their focus on the energies connecting the outer natural world and the inner spiritual one. Goesch joined Steiner's Anthroposophical Society in 1913, a year after its founding. He then took part in the construction of the first Goetheanum, the society's headquarters in Dornach, Switzerland—a building whose "appeal," per Steiner, "was to perceptive feeling, not to theoretical, intellectual cogitation" (fig. 2).[12]

During the war, Goesch worked as a civil servant in the post office before again being institutionalized from 1917 to 1919, this time in the town of Schwetz (today Świecie, Poland). It was there that he produced both figurative drawings and architectural fantasies that were sent in response to a call from Heidelberg University's psychiatric hospital, which sought to expand its holdings of works produced by patients in fellow institutions. This collection, established by renowned psychiatrist Emil Kraepelin in the late nineteenth century and con-

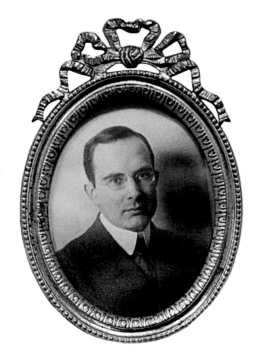

Fig. 3. Photographer unknown, portrait of Paul Goesch in medallion frame, c. 1920. Collection: Freundeskreis Paul Goesch e.V., Cologne.

tinued by Karl Wilmanns and Hans Prinzhorn in the early twentieth, would become known as the Sammlung Prinzhorn, and Goesch was to be one of the few artists in it with formal training.[13] Upon his release, Goesch moved back to Berlin and took a studio in his family's home (fig. 3).

In 1919, Goesch joined the leftist Work Council for Art—led by Taut, Behne, the painter César Klein, and the architect Walter Gropius—which sought to give a voice to art workers in the new government. That year he also became a member of the November Group, an association of Expressionist artists and architects named for the November Revolution of 1918; he would exhibit with them in the *Grosse Berliner Kunstausstellung* (Great Berlin Art Exhibition) in 1921, 1923, 1925, and 1929, even as he was institutionalized. Between 1919 and 1920, Goesch participated in the *Gläserne Kette* (Glass Chain), an epistolary circle of avant-garde architects throughout Germany

12. Rudolf Steiner, "The Building at Dornach," lecture IV, October 24, 1914. Trans. Dorothy S. Osmond. Rudolf Steiner Archive, GA 287, https://rsarchive.org/Lectures/GA287/English/UNK1958/BldDrn_index.html.
13. See Raphael Koenig, "Prinzhorn, Hans," in *The Modern Art Index Project*, Leonard A. Lauder Research Center for Modern Art, The Metropolitan Museum of Art, 2022, www.metmuseum.org/art/libraries-and-research-centers/leonard-lauder-research-center/research-resources/the-modern-art-index-project/prinzhorn.
14. Here Iain Boyd Whyte is quoting, with some skepticism, from Dennis Sharp, *Modern Architecture and Expressionism* (London: Longmans, 1966), 85.

See Iain Boyd Whyte, ed., *The Crystal Chain Letters: Architectural Fantasies by Bruno Taut and His Circle* (Cambridge, MA: MIT Press, 1985), 1. Boyd Whyte translates "Gläserne Kette" as Crystal Chain to express its "exotic and rarefied connotations," and its members' fascination with crystals, though the present text opts for the word's literal translation. The original members of the Glass Chain were Wilhelm Brückmann, Hermann Finsterlin, Paul Goesch, Jakobus Göttel, Walter Gropius, Wenzel Hablik, Hans Hansen, Carl Krayl, Hans Luckhardt, Wassili Luckhardt, Hans Scharoun, Bruno Taut, and Max Taut.

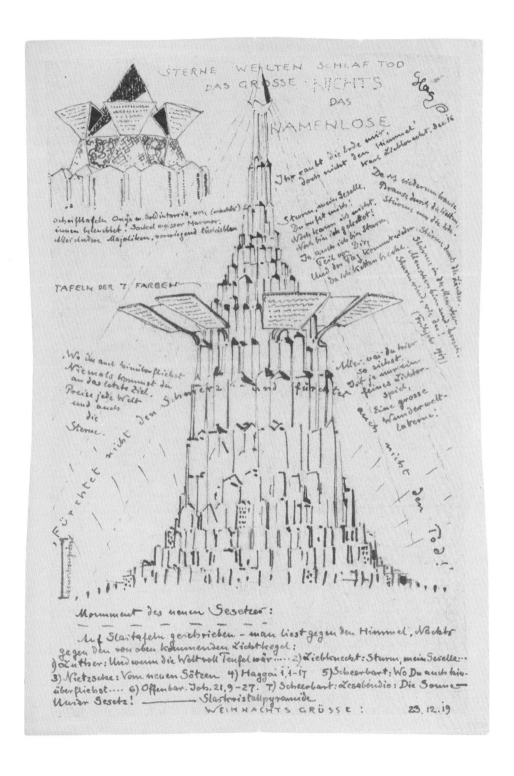

Fig. 4. Bruno Taut (German, 1880–1938), *Illustrated letter with a drawing of a project for the monument to the dead*, December 23, 1919. Reproductive copy on paper, 13 7/16 x 9 1/16 in. (34 1/8 x 23 cm). Centre Canadien d'Architecture/ Canadian Centre for Architecture, Montreal, DR1988:0023:003.

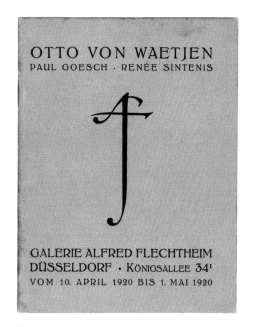

Fig. 5. Cover of *Otto von Waetjen, Paul Goesch, Renée Sintenis* (Dusseldorf: Galerie Alfred Flechtheim, 1920). Clark Art Institute Library, Rare Books.

Fig. 6. Hermann Finsterlin (German, 1887–1973), *Formal study*, 1920. Graphite and watercolor, with some gouache, 11 x 13 7/8 in. (28 x 35 1/4 cm). Centre Canadien d'Architecture/Canadian Centre for Architecture, Montreal, DR1988:0260.

that was organized by Taut and has, with only some exaggeration, been called "probably the most significant exchange of theoretical ideas on architecture" in the twentieth century (fig. 4).[14] Goesch circulated drawings and texts with the group, some of which were also published in Taut's journal *Frühlicht* (Dawn). The journal's editor clearly held Goesch in high esteem: Among the prominent architects represented in *Frühlicht*, more drawings by Goesch appear than by anyone but Finsterlin, his fellow Glass Chain member Carl Krayl, and Taut himself.[15]

In 1920, the taste-making Galerie Alfred Flechtheim in Dusseldorf, which represented artists including Wassily Kandinsky, Paul Klee, and Pablo Picasso, featured Goesch's work in a three-person exhibition (fig. 5). The same year, Gustav Hartlaub, director of the Kunsthalle Mannheim, acquired three drawings by Goesch for the museum's collection. It was these, as well as works acquired by what became the Sammlung Prinzhorn, that were displayed in one or more venues of the National Socialists' infamous touring exhibition *Entartete Kunst* (*Degenerate Art*), which opened in Munich in 1937.[16]

Already in July 1921, however, Goesch was again institutionalized, as he would remain, with brief interruptions, for the rest of his life. In 1940, Nazi doctors murdered Goesch in the former Brandenburg prison, which had become a killing facility (*Tötungsanstalt*) for the Aktion T4 involuntary euthanization program. This program would also murder some 300,000 other patients with mental illness, designated by the regime as "life unworthy of life" (*lebensunwertes Leben*).

FORM AND COLOR

What Goesch called his *phantastische Architekturformen* (fantastic architectural forms) often depict arches or passageways, freestanding or in facades.[17] We might read these as marking the way to another state—whether holiness, enlightenment, or utopia.[18] For a devout believer like Goesch, the portal is a charged architectural element, marking the boundary between profane and sacred realms, and in medieval Christian architecture representing "the gate of heaven."[19] Goesch was surely aware of the biblical symbolism of salvation as a kind of passage, for example in Christ's words: "I am the gate; whoever enters through me will be saved."[20] Larger-scale designs by Goesch suggest a *Volkspalast* or "house of the people," a type of quasi-sacral civic structure that preoccupied members of the Glass Chain. This typology is exemplified by what Taut called a *Stadtkrone* (*city crown*) in his influential book of the same name: a nondenominational structure that plays a central role, spatially and spiritually, in the city.[21]

Compared to his colleagues in the Glass Chain, Goesch's formal range seems to have been unlimited. While others had certain hallmarks—Wenzel Hablik favored crystal structures grown from rock, while Hermann Finsterlin's biomorphic buildings often resemble funghi or slugs (fig. 6)—Goesch was restless in his experimentation. As he wrote to other members of the Glass Chain: "Every form (ornament) can be ground plan, elevation, ornament, and town plan, for example: circle, parabola, spiral, and also freely drawn curves."[22] And while most of his peers rejected historical styles, Goesch gathered up global forms like so much spolia, recombining them in a pastiche that might be considered neo-historicist or even proto-postmodern, for its playfulness and pluralism. In his drawings we see encrusted baroque facades, Khmer-style temples, and anthropomorphic grottoes; columns might be topped with Egyptianate floral capitals, winged angels, or writhing abstractions. In Goesch's work, ornament does not merely embellish buildings, it overtakes them, and might itself become the subject matter (pp. 92–97). With his fluid sense of scale, Goesch often imagined microarchitectural ornament, too, extending the Gothic penchant for stone canopies that cover altars or niches and mimic the overarching cathedral, or historiated capitals crowded with miniature people and even buildings. As if to summarize his approach to form and history, Goesch once urged: "Don't be so serious!"[23]

15. Other architects who appear in the pages of *Frühlicht* include Antonio Gaudi, Walter Gropius, Erich Mendelsohn, and Ludwig Mies van der Rohe. See Bruno Taut, *Frühlicht 1920–1922: Eine Folge für die Verwirklichung des neuen Baugedankens*, ed. Ulrich Conrads, Bauwelt Fundamente 8 (Berlin: Ullstein, 1963).
16. For more on the *Degenerate Art* exhibition, see Stephanie Barron, ed., *Degenerate Art: The Fate of the Avant-Garde in Nazi Germany* (Los Angeles: Los Angeles County Museum of Art; New York: H. N. Abrams, 1991).
17. Adolf Behne, "Werkstattbesuche III: Paul Gösch," *Der Cicerone: Halbmon tsschrift für Künstler, Kunstfreunde, und Sammler* 12, no. 4 (1920): 150. Though Goesch's name was sometimes rendered "Gösch," its spelling in this essay is based on that used by the artist, his family, and other scholars working today.
18. For more on avant-garde conceptions of utopia, see Timothy O. Benson, ed., *Expressionist Utopias: Paradise, Metropolis, Architectural Fantasy* (Berkeley: University of California Press; Los Angeles: Los Angeles County Museum of Art, 2001).
19. See Calvin B. Kendall, *The Allegory of the Church: Romanesque Portals*

and their Verse Inscriptions (Toronto: University of Toronto Press, 1998).
20. John 10:9, the New International Version (NIV), *Biblia*, https://biblia.com/bible/esv/john/10/9. For first mentioning this passage to me, I am grateful to Stefanie Poley, and to Hemmo Müller-Suur, who shared it with her.
21. See Bruno Taut, *Die Stadtkrone* (Jena: E. Diedrichs, 1919). For an English translation, see Matthew Mindrup and Ulrike Altenmüller-Lewis, eds., *The City Crown* by Bruno Taut (New York: Routledge, 2016). Taut's models for such buildings include Gothic cathedrals, Ottoman mosques, and Hindu and Buddhist temples.
22. Paul Goesch, "Architektonische Aphorismen," *Frühlicht 5 [Stadtbaukunst alter und neuer Zeit 1*, no. 5 (March 1920)]: 79–80. Translated in Boyd Whyte, *The Crystal Chain Letters*, 62.
23. Paul Goesch, "Anregungen," *Frühlicht 12 [Stadtbaukunst alter und neuer Zeit 1*, no. 12 (June 1920)]: 191–92. Translated in Boyd Whyte, *The Crystal Chain Letters*, 114.

Fig. 7. Bruno Taut, *Glashaus* (Glass pavilion), Werkbund Exhibition, Cologne, 1914.

Goesch's kaleidoscopic palette and improbably successful juxtaposition of pigments also sets his work apart. He applied these colors in pointillist dabs in early drawings and washy blocks, outlined in graphite or ink, in later ones. Besides looking inward to find his exuberant color sense, Goesch surely looked back to the stained glass of Gothic cathedrals, to nineteenth-century revelations about polychromy in the ancient world, and to his architect colleagues, who were convinced of the transformative potential of color imbued in glass.[24] Paul Scheerbart's influential book *Glass Architecture*, of 1914, presented 111 points on the subject, advocating for colored glass windows, glass mosaic laid into concrete, and construction with "glass brick . . . in every possible color and form."[25] Taut, to whom the book is dedicated, in turn devoted his prismatic *Glashaus* (Glass pavilion), built for the 1914 Cologne Werkbund Exhibition, to Scheerbart, inscribing its frieze with mottoes by the poet, such as: "Without a palace of glass / Life is a burdensome task" (fig. 7).[26] Even when depicting historical forms, the effect of Goesch's prismatic palette—for his peers as for us today— was to reenchant the existing world and the very possibilities of architecture.

Across Goesch's drawings, his style of rendering and level of finish vary greatly, from loose, energetic linework to lapidary precision, from the seemingly naive to the manifestly professional. He took

Fig. 8. Adolf Behne's "studio visit" with Paul Goesch, whose self-portait appears on the righthand page. "Werkstattbesuche III: Paul Gösch," *Der Cicerone: Halbmonatsschrift für Künstler, Kunstfreunde, und Sammle*r vol. 12, no. 4 (February 1920), 150–51. Clark Art Institute Library.

pains, in a text of great sensitivity, to explain these distinctions to his peers. Any school child, Goesch observes, knows the shame of badly drawing and then continuously redrawing a figure. "But if you approach these distortions that come, so to speak, from 'yourself' with more understanding, you will discover in yourself a much higher level of creative ability than the one you were initially trying to develop. This ability makes visible to us those aspects of the objects that we mentally hanker after (subconsciously and supraconsciously) and reveals how the objects relate to us."[27] In trying to accurately draw a horse, he continues, "The person doing the drawing might, for example, give the horse a facial expression that caricatures his own face. In this instance, it is more important for him to portray something of his own suffering, for example his helplessness, than to merely imitate the horse. Only when the artist has come to terms emotionally with this phase of creativity will he be able to produce work that also meets the demands of correctness and formal beauty.

24. See Vinzenz Brinkmann, Renee Dreyfus, and Ulrike Koch-Brinkmann, *Gods in Color: Polychromy in the Ancient World* (Munich: Prestel, 2017).
25. Paul Scheerbart, *Glass Architecture*, in Josiah McElheny and Christine Burgin, eds., *Glass! Love!! Perpetual Motion!!!: A Paul Scheerbart Reader* (New York: Christine Burgin; Chicago: University of Chicago Press, 2014), 50. For the original German, see Paul Scheerbart, *Glasarchitektur* (Berlin: Verlag der Sturm, 1914).
26. *Ohne einen Glaspalast / Ist das Leben eine Last.* This and other mottoes translated in McElheny and Burgin, *Glass! Love!! Perpetual Motion!!!*, 135–36.
27. Paul Goesch, "Allgemeine Kunstbetrachtungen," *Frühlicht 10 [Stadtbaukunst alter und neuer Zeit* 1, no. 10 (May 1920)]: 158–59. Translated in Boyd Whyte, *The Crystal Chain Letters*, 69.

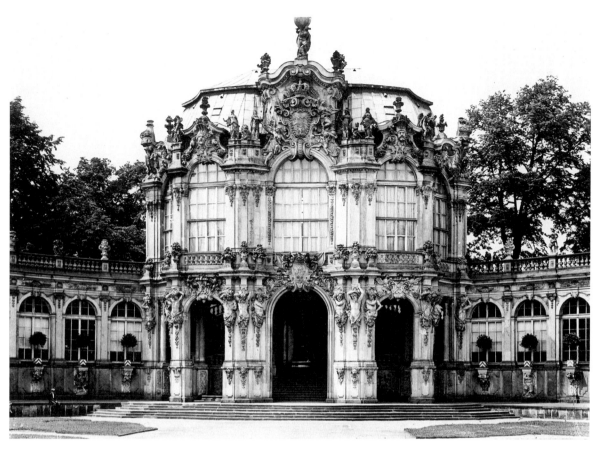

Fig. 9. Paul Wolff (German, 1876–1947), *Wall pavilion in the Zwinger Palace, Dresden, Germany*, c. 1920–30. Black-and-white photograph, 5 1/8 x 7 1/8 in. (13 x 18 cm). SLUB Dresden/Deutsche Fotothek.

Expressionism is trying to achieve this progression." What Goesch concludes by identifying as "the modern tendency not to eliminate the instinct for ugliness but to set it free and ennoble it" is praised by Taut, in an appended note, as a paradigm shift: "The cold, rational notion of correctness is being transformed," writes Taut, "in favor of artistic understanding and feeling. To each his own and to art its own 'correctness.'"[28]

INSIDE AND OUT

When Adolf Behne described his visit to Goesch's studio in 1920, he compared his subject to a monk, declaring that Goesch "lives withdrawn from the 'world'—and that is exactly why he is in the world (fig. 8)."[29] Behne's text begins with a brief biography, in which Goesch is quoted describing his influences: that he has long been moved by the Baroque architecture of the Zwinger palace in Dresden (fig. 9) and Louvre in Paris, and by the temple complexes of Cambodia such as Angkor Wat (fig. 10). Goesch cites art historian Heinrich Wölfflin's study of the Italian Baroque as a "literary impression," but Behne claims—perhaps dubiously—that "Goesch knows little of the new art.

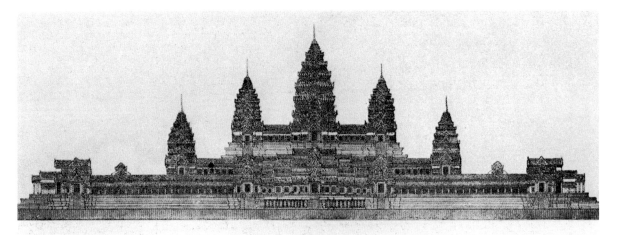

23. Angkor-Vat

Fig. 10. Angkor Wat, as pictured in Bruno Taut, *Die Stadtkrone* (*The City Crown*; Jena: E. Diedrichs, 1919), 34.

In drawing and watercolor he renders his dreams, to which a mysterious necessity leads him."[30] Employing a trope typical of the reception of art variously labeled "naive" or "folk" at this time, Behne observes: "His drawings appear timeless," and adds, as if to echo artist Paul Klee's contemporary sentiments, "Just as children's drawings are timeless, as folk art is timeless—as art is timeless."[31] Indeed, Behne concludes with soaring praise: "I can't think of anyone besides Paul Klee who is as close to the creative source of ornament as Goesch"—this source being the irrational and variously playful and tormented depths of the psyche, available, in principle, to anyone.

However tempting, it would be a mistake to pathologize Goesch's art and attempt to read his mental state into it. Indeed, the drawings in this publication originate mainly from a two-year period (October 1919 to July 1921) during which the artist was not institutionalized, and many resemble ones made during his acute periods, as well as the works of other Expressionists.[32] Likewise, the diagnosis of schizophrenia—a new term at the time, and one initially used to refer to what are now understood as multiple conditions—should not be considered secure.[33] Finally, a diagnosis cannot be derived from an artwork, as even Prinzhorn himself came to acknowledge.[34] For these reasons,

28. Bruno Taut, translated in Boyd Whyte, 70.
29. Behne, *Werkstattbesuche*, 150.
30. See Heinrich Wölfflin, *Renaissance und Barock: Eine Untersuchung über Wesen und Entstehung des Barockstils in Italien* (Munich: T. Ackermann, 1888). For an English translation, see Heinrich Wölfflin, *Renaissance and Baroque*, trans. Kathrin Simon (Ithaca, NY: Cornell University Press, 1966).
31. Praising the art of children as a creative stimulus, in 1912, Klee observed: "Parallel phenomena are provided by the works of the mentally diseased; neither childish behavior nor madness are insulting words here, as they commonly are. All this is to be taken very seriously, more seriously than all the public galleries, when it comes to reforming today's art." Paul Klee, *The Diaries of Paul Klee, 1898–1918*, ed. Felix Klee (Berkeley: University of California Press, 1964), 266. See also John M. MacGregor, *The Discovery of the Art of the Insane* (Princeton, NJ: Princeton University Press, 1989), 222 ff.
32. See Hal Foster, "Blinded Insights: On the Modernist Reception of the Art of the Mentally Ill," *October* 97 (2001): 3–30.
33. The illness was known as "dementia praecox" before the Swiss psychiatrist Eugen Bleuler coined "schizophrenia." See Eugen Bleuler, *Dementia praecox, oder, Gruppe der Schizophrenien* (Leipzig: Franz Deuticke, 1911).
34. See Raphael Koenig, "Art Beyond the Norms: Art of the Insane, Art Brut, and the Avant-Garde from Prinzhorn to Dubuffet (1922–1949)" (PhD diss., Harvard University, 2018), 53.

Fig. 11. Paul Goesch (German, 1885–1940), *I will be Famous (Self-Portrait)*, c. 1920. India ink on paper, 6 3/8 x 8 1/4 in. (16.3 x 20.8 cm). Berlinische Galerie, BG-G 1529/78.

whether Goesch's drawing *I will be Famous (Self-Portrait)*, (fig. 11), in which his name appears on every building and advertising column of the city, reflects a delusion of grandeur or playful self-ironizing is unclear. Whatever the source of his visions, it is their quality that renders them so compelling.

Besides architectural facades, Goesch's most frequent subject is the human face. These faces usually belong to anonymous figures, to Christ or the Madonna, or to the artist himself (fig. 12). It is perhaps no accident that Goesch favored the etymologically twinned "fronts" of buildings and of people: each presents an axially symmetrical scaffold onto which the artist could project his visions and a field of play for experiments in form, color, and mark-making. Both also offer communicative potential. Goesch's people might figure in religious or mythological narratives, or ones invented by the artist. And for an architect trained in the historical styles and their cultural and structural

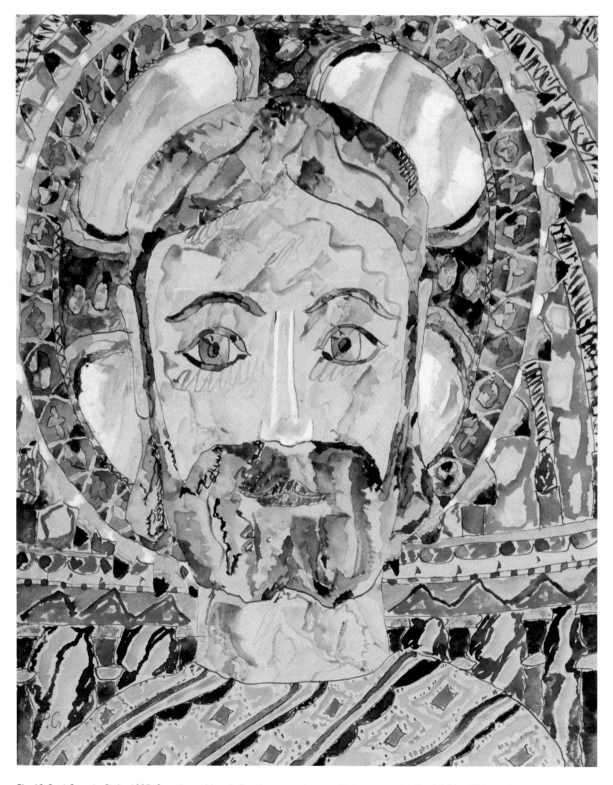

Fig. 12. Paul Goesch, *Christ*, 1923. Gouache, gold, and silver bronze and pen and ink on paper, 8 1/4 x 6 1/2 in. (20.9 x 16.5 cm). Berlinische Galerie, BG-G 1539/78.

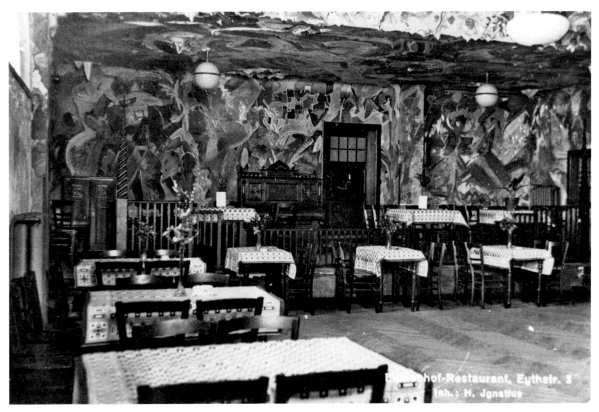

Fig. 13. Postcard of Paul Goesch dining room mural, Siedlung Lindenhof, Ledigenheim, Berlin, 1921. Berliner Geschichtswerkstatt e. V., Sign. LIN1 1-56.

signification, buildings also speak, perhaps as volubly as his early design for a chapel whose exterior teems with human heads (p. 87). Goesch's drawings no doubt contain symbolic and narrative significance legible only to the artist. But they also offer us passageways to new worlds, whether distant or close at hand.

CODA

Paul Goesch was an architect who never built. Yet he did realize artistic projects. In 1908, Goesch painted a mural in a gymnasium near Dresden with *Scenes from the Life of Buddha*. In 1922, his mural *Flight from Egypt* appeared in the attic of the director's building of the institution in Göttingen where he was a patient. And in 1921, with Franz Mutzenbecher, Goesch painted the ballroom of a new social housing complex designed by Taut (fig. 13). From what pictures survive, this was a phantasmagoria of abstract, technicolor forms teeming across the walls and ceiling. The building was destroyed by Allied bombing in the Second World War. Goesch's ecstatic design within Taut's cautiously modernist building is a fitting metaphor for his place in early twentieth-century architecture, and that of Expressionism more broadly—of an interiority both spatial and psychic, repressed and then erased, on the way to Functionalism and followed by fascism.

Work Council co-chair Walter Gropius had founded the Bauhaus school in 1919 to unite the arts and crafts in the project of architecture, and illustrated his announcement with a woodcut by Lyonel Feininger showing a crystalline cathedral thrusting skyward. Yet by 1923, under the influence of Soviet Constructivism, the Bauhaus committed itself to "a new unity" between art and technology, and largely disavowed its quasi-mystical origins. The same year, Behne, who had been Expressionism's most ardent champion, would write *Der moderne Zweckbau* (*The Modern Functional Building*), ahead of a decade in which functionality, not feeling, would be the modernist mantra.[35] It was also in this year that the hyperinflationary Weimar currency stabilized and sober buildings in glass and steel began to sprout up around Germany. In 1925, Gustav Hartlaub—who had five years earlier acquired Goesch's drawings for his museum in Mannheim—popularized the term *Neue Sachlichkeit* (New Objectivity) to describe a matter-of-fact, post-expressionist tendency in art.[36]

Yet this, too, was short-lived. Following its rise in 1933, the Third Reich either crushed or coopted various strains of modernism, with dire consequences for artists and architects—and especially those deemed ethnically, sexually, or psychologically aberrant. Under fascism, Goesch's ungovernable visions became untenable. On paper, his unique way of building remains.

35. Adolf Behne, *Der moderne Zweckbau* (Munich: Drei Masken Verlag, 1926). For an English translation, see Adolf Behne, *The Modern Functional Building*, trans. Michael Robinson (Santa Monica: Getty Research Institute for the History of Art and the Humanities, 1996).

36. Gustav Friedrich Hartlaub, *"Neue Sachlichkeit": Deutsche Malerei seit dem Expressionismus* (Mannheim: Städtische Kunsthalle Mannheim, 1925). See also Stephanie Barron and Sabine Eckmann, eds., *New Objectivity: Modern German Art in the Weimar Republic, 1919–1933* (Los Angeles: Los Angeles County Museum of Art; Munich: Prestel, 2015).

Thresholds: The Reception of Paul Goesch

Raphael Koenig

The reception history of Paul Goesch offers a powerful illustration of the vagaries of artistic categories, and of the problematic interplay of art and mental health in twentieth-century critical and scientific discourses.

With their profusion of fantastic architectures, sacred iconographies, and Elysian idylls, recorded on paper in gouache, graphite, or ink (fig. 14), Goesch's drawings resonate with the general sense of radical upheaval and symbolic disorientation that characterized Germany in the immediate aftermath of the First World War—which also corresponded to the artist's most productive period. As a member of the interwar avant-garde, Goesch took an active part in initiatives that decisively shaped the cultural landscape of Weimar Germany.[1]

However, it is certainly a paradox for a movement that professed untrammeled fidelity to one's inner vision[2] that Expressionists considered Goesch simultaneously as a paragon of their values and as a relative outlier.[3] The unconventional nature of his work could partly explain such critical reception, as it at once combines seriality—variations on specific motifs such as gates or schematized portraits—and eclecticism. Visual quotations drawn from a vast repertoire of historical styles and time periods, echoing Goesch's fondness for turn-of-the century historicism, were likewise met with skepticism by some of his avant-garde colleagues who saw them as a late Wilhelminian anachronism.[4]

Nonetheless, beyond the visual qualities of his work, Goesch's fraught reception within the German avant-gardes is also a result of his biography. From 1909 onward, Goesch made increasingly lengthy stays in psychiatric institutions; he was then institutionalized continuously from May 1923 to 1940, when he was murdered by Nazi authorities as part of the Aktion T4 program that exterminated mental health patients. Goesch is not the only German Expressionist to have experienced mental health issues.[5] He remains exceptional, however, insofar as his mental health history had a lasting impact on the reception of his work, leading to his drawings being exhibited simultaneously as both avant-garde and patient art, then variously labeled as "pathological art" or "art of the insane," while remaining marginal in both categories.[6]

BOUNDARY TROUBLE[7]

In 1922, the celebrated graphic artist Alfred Kubin (1877–1959), also known for his fantastic novel *The Other Side* (1908), visited the collection of patient art in the psychiatric hospital at Heidelberg University, which was made up of contributions from patients in mental health institutions across Germany, Austria, and Switzerland. His visit was an important one, as the aim of the director

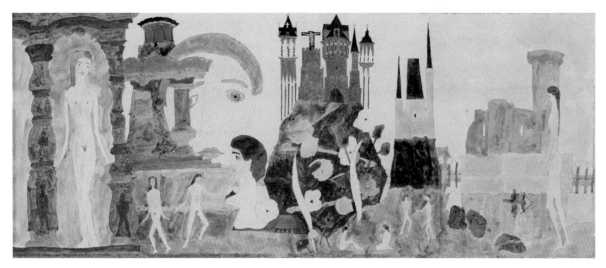

Fig 14. Paul Goesch (German, 1885–1940), *Fantastic Landscape*, c. 1917–19. Gouache over pencil on paper, 18 1/2 x 7 5/8 in. (47 x 19.3 cm). © Prinzhorn Collection, University Hospital Heidelberg, no. 1090b.

of the clinic, Karl Wilmanns, and of his assistant, Hans Prinzhorn, was to establish a permanent Museum for Pathological Art.[8] The works presented to Kubin by Wilmanns were meant as a proof of concept, increasing the visibility of the project as part of a fundraising initiative. Kubin's visit was largely successful: he published an enthusiastic account of the collection titled "The Art of the Insane" in the leading Expressionist journal *Das Kunstblatt* in May 1922,[9] in which he praised the "wonders of artistic spirit" featured in it and explicitly relayed Wilmanns's call for a "benefactor [who would fund] a permanent exhibition gallery." One artist, however, failed to secure Kubin's approval: "We saw a few works—church interiors, schematic representations of saints, and portraits—by a professional artist, a schizophrenic architect. He was the least interesting artist in the collection, with his sophisticated temperament and his unpleasant technical 'know-how.' All other artists were self-taught."[10]

1. For a broader contextualization of Goesch's architectural activities, see Robert Wiesenberger, "Passages: The Work of Paul Goesch," p. 10, in the present volume.
2. Expressionism defined itself in opposition to Impressionism, which it decried as a realistic representation amounting to mere optical distraction. Goesch himself proclaimed the centrality of "inner experience" *(inneres Erlebnis)* for artistic creation. On this point, see Eva-Maria Barkhofen, "Architektur im Kopf. Paul Goesch und die Gläserne Kette. Theorien zur utopischen Architektur und Expressionismus," in Annelie Lütgens, ed., *Visionäre der Moderne: Paul Scheerbart, Bruno Taut, Paul Goesch/Modern Visionaries: Paul Scheerbart, Bruno Taut, Paul Goesch* (Berlin: Berlinische Galerie; Zurich: Scheidegger & Spiess, 2016), 155.
3. In this regard, the somewhat uneasy reception of the late work of Antonin Artaud within the Surrealist movement could provide a useful point of comparison; see, for instance, André Breton, "Hommage à Antonin Artaud," in André Breton, *La clé des champs* (Paris: J.J. Pauvert, 1967).
4. Goesch professed his affection for the stylistic quotations of late-nineteenth century historicist architecture, a position that set him apart from other members of the Glass Chain epistolary collective. Barkhofen, "Architektur im Kopf. Paul Goesch und die Gläserne Kette," 155.
5. Ernst Ludwig Kirchner was institutionalized at the Bellevue Sanatorium, Switzerland, in 1917–18, where he produced a number of paintings. Bettina

Gockel, *Die Pathologisierung des Künstlers: Künstlerlegenden der Moderne 1880 bis 1930* (Berlin: Akademie Verlag, 2009), 105–54.
6. In 1919, for instance, Goesch's work was on display in two very different institutional settings: the psychiatric hospital at Heidelberg University, as part of the projected Museum for Pathological Art, and in the collective avant-garde exhibition For *Unknown Architects* at the blue-chip gallery Graphisches Kabinett J.B. Neumann on Berlin's Kurfürstendamm.
7. The notion of "boundary trouble" was coined by Lynne Cooke, who applied it to the complex reception history of "outlying" works in the twentieth century and their impact on avant-garde aesthetics, leading to a critical reappraisal of the boundaries of both categories. See Lynne Cooke, ed., *Boundary Trouble in American Vanguard Art, 1920–2020* (New Haven, CT: Yale University Press, 2022).
8. On the projected Museum for Pathological Art and the history of the collection, see Bettina Brand-Claussen, "Das 'Museum für Pathologische Kunst' in Heidelberg. Von den Anfängen bis 1945," in *Wahnsinnige Schönheit: Prinzhorn Sammlung*, ed. Christoph Hollender and Hermann Lelle, exh. cat. (Heidelberg: Schloss Heidelberg and Kunsturgeschichtliches Museum Osnabrück, 1996), 7–23.
9. Alfred Kubin, "Die Kunst der Irren," *Das Kunstblatt*, May 5, 1922.
10. Kubin, "Die Kunst der Irren," 185–86. Translation by the author.

The indications given by Kubin unambiguously point to the work of Goesch. His stay at the psychiatric hospital in Schwetz from March 1917 to October 1919 corresponded to a moment of heightened productivity, during which Goesch created around a thousand drawings.[11] In 1919, as Wilmanns and Prinzhorn solicited contributions from psychiatric institutions to be added to the holdings of the future Museum for Pathological Art, medical staff at the Schwetz hospital contributed twenty-seven drawings by Goesch and a 193-page book of sketches.[12]

Kubin's negative evaluation probably echoed Prinzhorn's own reservations. Apart from a single unpublished annotation beneath Goesch's drawing *The Dismembered Horus* (fig. 15),[13] Prinzhorn made no mention of Goesch's work, which is conspicuously absent from his pivotal 1922 monograph *The Artistry of the Mentally Ill*. As Prinzhorn explicitly sought out the visual production of patients with no previous artistic training, Goesch's dual affiliation as a patient in a psychiatric institution and a trained architect belonging to the Expressionist avant-garde seemed incompatible with the ideological tenets of Prinzhorn's project.[14] Under the influence of the vitalist philosopher Ludwig Klages,[15] Prinzhorn espoused a peculiar anti-rationalist worldview according to which free will was an obstacle to humanity's harmonious development.[16] While extreme, Prinzhorn's views echoed a general fascination with the limits and potential abolition of free will in Weimar Germany that also led to a popular interest in hypnosis. This gave rise to a cinematic milestone such as Robert Wiene's *The Cabinet of Dr. Caligari* (1920)[17] as well as to heated legal debates on the responsibility of persons presumed to be under hypnotic suggestion.[18]

Prinzhorn thus valued the work of the artists discussed in his monograph, labelled "Schizophrenic Masters," as examples of the type of creativity that he claimed might be unleashed by the suspension of free will in states of altered consciousness, which he associated with conditions such as schizophrenia.[19] Prinzhorn summarized this assertion by using a turn of phrase from the Gospels, "they don't know what they are doing," which for him had a positive connotation.[20] Prinzhorn feared that the training, critical self-awareness, and art historical knowledge acquired by professional artists such as Goesch in the course of their careers—of the kind implied by Goesch's playful layering of visual quotations, for example his self-portrait as a kneeling medieval *orant* in an homage to post-Impressionism (fig. 16)—might hinder the untrammeled expression of the type of spontaneous "form-making impulse" (*Gestaltungsdrang*) he problematically claimed as the bedrock of artistic creation. Prinzhorn thus found it necessary to leave art produced by patients also active as professional artists out of the scope of his inquiry altogether.[21]

Ironically, the editor of *Das Kunstblatt*, Paul Westheim, had taken a stance diametric to Kubin's in a previous issue of the journal (September 1921), praising the simplicity and "unphilosophical"[22] nature of Goesch's work, which he contrasted with Paul Klee's overly self-aware compositions. While

Fig. 15. Paul Goesch, *The Dismembered Horus*, undated. Gouache over pencil on laid paper, 6 1/2 x 8 1/8 in. (16.5 x 20.6 cm). © Prinzhorn Collection, University Hospital Heidelberg, no. 881.

this time, the binary, reductive opposition between naive and savant is reversed in Goesch's favor, the compliment paid to him is a backhanded one. Dwelling on Goesch's "romantic," visionary qualities, and obliquely alluding to his mental health issues, Westheim absolutizes and essentializes Goesch's singularity to the extent that he not only obfuscates his active involvement with the

11. Schwetz, West Prussia, is today Świecie, Poland.
12. Stefanie Poley surmises that Goesch might have overseen this selection himself. Stefanie Poley, "Über Seblbstfindung und Selbstauflösung," in *Kunst und Wahn* (Cologne and Vienna: Bank Austria), 253n6. However, inclusion in a collection of "Pathological Art" might have been regarded as a dubious honor for a professional artist; in fact, a number of contributions were sent to Heidelberg and accessioned into the collection without the knowledge or consent of their authors—a fact recognized as problematic by Karl Wilmanns, who suggested a different policy for acquiring artworks that would require the consent of the artist-patients involved, and financial compensation for the artworks acquired (Brand-Claussen, "Das 'Museum für Pathologische Kunst' in Heidelberg," 18–19).
13. The only account of Goesch's work that we have from Prinzhorn is a single, rather tepid handwritten notation: "bemerkenswert," literally "worth noticing" or simply "interesting." On this point, see Sabine Hohnholz, "'Remarkable': Hans Prinzhorn, his Collection and Paul Goesch," in Lütgens, ed., *Modern Visionaries*, 167.
14. On this point, see Thomas Röske, "Paul Goesch – zwischen Avantgarde und Anstalt," in *Paul Goesch, 1885–1940: Zwischen Avantgarde und Anstalt,* ed. Thomas Röske and Prinzhorn-Sammlung der Psychiatrischen

Universitätsklinik Heidelberg (Heidelberg: Wunderhorn, 2016), 27.
15. On Klages's anti-rationalism and its disturbing political implications, see Nitzan Lebovic, *The Philosophy of Life and Death: Ludwig Klages and the Rise of a Nazi Biopolitics* (New York: Palgrave Macmillan, 2013).
16. On Prinzhorn's indebtedness to Klages and the extent of his anti-rationalist beliefs, see the useful summary in Ernest Seillière, *Sur la psychologie du romantisme allemand* (Paris: 1933), 133–53.
17. See Kracauer's equally canonical discussion of the political implications of such depictions of the abolition of free will in Siegfried Kracauer, *From Caligari to Hitler: A Psychological History of the German Film* (Princeton, NJ: Princeton University Press, 1947).
18. See the excellent discussion of the topic in Anthony D. Kauders, "Negotiating Free Will: Hypnosis and Crime in Early Twentieth-Century Germany," *Historical Journal* 60, no. 4 (2017): 1047–69.
19. Prinzhorn was also convinced that psychotropic drugs—he experimented with mescaline as he was writing *The Artistry of the Mentally Ill*—might be able to artificially and temporarily recreate such suspension of free will, echoing since debunked medical theories describing the effects of mescaline as "psychotomimetic," i.e. creating a state of "temporary schizophrenia." See Jos ten Berge, "Experimental Madness in Heidelberg," in *Drugs in the Arts: From Opium to LSD, 1798–1968* (Amsterdam: Free

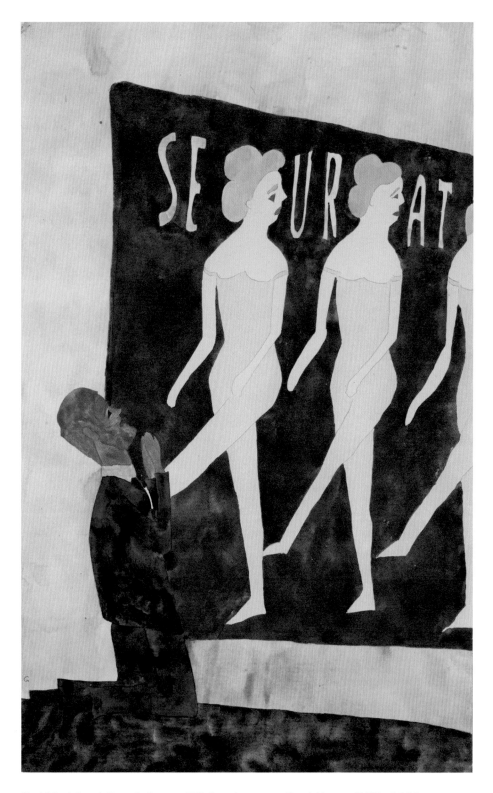

Fig. 16. Paul Goesch, *Prayer for Seurat*, c. 1920. Gouache over pencil on laid paper, 12 7/8 x 8 1/8 in. (32.8 x 20.5 cm). © Prinzhorn Collection, University Hospital Heidelberg, no. 1090/149.

Expressionist avant-garde, but muses on whether Goesch could be called an artist at all:

> Paul Goesch. What is he, how does he stand in relation to us? A painter? An architect? An artist? In fact, none of the above. He can't be put in a category, he has something of an artist, but he is also different. In the realm of botany, one would say that he is a specific variety in and of himself. . . . He couldn't take root in life, in this order of things that is defined by us normal people, and in which we can orient ourselves. . . . Maybe it isn't art at all. Maybe it is a form of self-forgetting, of astonishment, but it may also possess this je-ne-sais-quoi that no artist could have achieved.[23]

Discussions of Goesch's oeuvre in the art criticism of the early 1920s thus labored under a strange paradox: He was successively deemed too "savant" to belong to the emerging canon of the "art of the insane," and too "naive" to be labeled an avant-garde artist.

Fraught as it was, Goesch's visibility was also short-lived: from the mid-1920s until the early 1960s,[24] he largely disappeared from the art historical record. His work was slowly "rediscovered" in the context of the growing interest in "fantastic architecture," for example in Ulrich Conrad and Hans Sperlich's 1960 monograph on the subject, in which Goesch is briefly mentioned.[25] That same year, three drawings were displayed alongside works by Goesch's avant-garde colleagues in the pivotal exhibition *Berlin—Ort der Freiheit für die Kunst* (Berlin—A Place for Freedom in the Arts) curated by Leopold Reidemeister at the Nationalgalerie, Berlin.[26] Goesch's most notable post-1945 breakthrough, however, was the exhibition *Paul Goesch—Aquarelle und Zeichnungen* (Paul Goesch—Watercolors and Drawings) curated by Eberard Roters at the Berlinische Galerie, Berlin, in 1976. In a striking reversal of fortune, the first-ever monographic exhibition dedicated to Goesch, made possible by the rediscovery of a large number of well-preserved works on paper owned by his relatives, was also the Berlinische Galerie's first exhibition dedicated to a single artist.[27]

University of Amsterdam Press, 2004), 279–84. See also Thomas Röske, "Erdentrückung 1922: Hans Prinzhorn im Meskalin-Rausch," in *Rausch im Bild – Bilderrausch: Drogen als Medien von Kunst in den 70er Jahren* (Heidelberg: Sammlung Prinzhorn, 2004), 117–26.

20. Hans Prinzhorn, *Bildnerei der Geisteskranken* (Berlin: Julius Springer, 1922), 343n75, probably echoing Luke 23:34, the New International Version (NIV): "Jesus said, 'Father, forgive them, for they do not know what they are doing.'"

21. In 1926, Prinzhorn hinted at a new book in which he would discuss professional artists; based on an allusion in the article by Ernst Maschmeyer discussed in this essay, and other circumstantial evidence, Thomas Röske convincingly argues that Prinzhorn might have intended to include an essay on Paul Goesch in this monograph. See Röske, "Paul Goesch – zwischen Avantgarde und Anstalt," in Röske, ed., *Paul Goesch, 1885–1940*, 27. It is perhaps equally significant that this project didnot come to fruition, as Prinzhorn's focus remained largely on non-professional artists, including his 1926 monograph *Bildnerei der Gefangenen* (The Artistry of Prisoners).

22. In this regard, Westheim's characterization can easily be debunked by merely mentioning the existence of Goesch's published theoretical writings on artistic production, architecture, and ornament.

23. Paul Westheim, "Paul Goesch," *Das Kunstblatt* 9 (September 1921). Reprinted in Lütgens, ed., *Modern Visionaries*, with an introduction by Lütgens, 123–37.

24. The year 1923 corresponds to Goesch's last contribution to an avant-garde publication as well as to his definitive institutionalization.

25. See Ulrich Conrads and Hans Sperlich, *Phantastische Architektur* (Stuttgart: G. Hatje, 1960).

26. Works by Goesch were also included in a 1963 exhibition dedicated to the Glass Chain and in Helga Kliemann's 1969 monograph on the November Group. See Oswald Mathias Ungers and Udo Kultermann, *Die Gläserne Kette: Visionäre Architekturen aus dem Kreis um Bruno Taut, 1919–1920* (Leverkusen: Museum Leverkusen, Schloß Morsbroich; Berlin: Akademie der Künste, 1963); Helga Kliemann, *Die Novembergruppe* (Berlin: Deutsche Gesellschaft für Bildende Kunst und Gebr. Mann Verlag, 1969).

27. See Eberard Roters, "Paul Goesch," in *Paul Goesch—Aquarelle und Zeichnungen* (Berlin: Berlinische Galerie, 1976), 6–10.

akuten Phasen. Aber es ist sehr bemerkenswert, daß in Epochen, in denen die Produktion scheinbar erlahmt und etwa zu kümmerlichen dadaistischen „Zeichnungen in Material" führt, doch immer wieder gleichzeitig einzelne geschmackvolle Bilder entstehen. So läßt sich ein durchgreifender Parallelismus zwischen klinischem Verlauf und ästhetischem Wert der Bildnerei nicht sicherstellen, wenn auch ein Einfluß nicht ganz zu verkennen ist.

 Der Vergleich mit unserem ersten Fall zeigt nun ferner, daß es sich bei den vorgebildeten Mechanismen, die durch die Psychose aktiviert wurden, um eine ungewöhnliche künstlerische Begabung handelt, deren

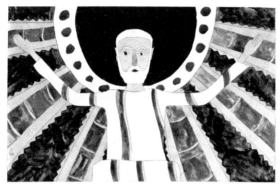

Abb. 5. „Gott-Vater." Aquarell 24,5×16 cm. 1923.
Nach einer Vision, die grau erschien und ein anderes, nicht erkennbares Bild verdeckte.

Anlage sich übrigens, ebenso wie die zur psychischen Erkrankung, auch bei anderen Familiengliedern nachweisen läßt.

 In der Tat ist der Kranke künstlerisch, gerade auch in der Zeit ausgebildeter Schizophrenie, von sehr sachverständigen Beurteilern durchaus ernst genommen worden. Seine Arbeiten wurden in Fachzeitschriften mehrfach in Sonderaufsätzen behandelt.

 Bei dem ersten Fall bleibt trotz ihres Ausdruckswertes die Malerei doch völlig befangen in der steifen Ungeschicklichkeit des künstlerisch Unkultivierten. Bei dem zweiten Kranken dagegen verraten selbst die im ganzen als Schmierereien anzusehenden Arbeiten oft noch in Einzelheiten, z. B. in dem zarten, lockeren Strich oder in der Farbenmischung die Einwirkung künstlerischen Instinkts. Und trotz aller Bizarrerie und Primitivität der !dee und Ausführung bietet eine große Anzahl

Fig. 17. Ernst Maschmeyer, "Ein Beitrag zur Kunst der Schizophrenen" ("A Contribution on the Art of Schizophrenics"), *Archiv für Psychiatrie und Nervenkrankheiten* 78 (1926), 510–21.

THE ARTIST AS PATIENT

During his art historical obscurity, however, Goesch was discussed in a different institutional setting: as an object of anonymized case studies within medical discourses. The work's trajectory in these contexts, and Goesch's personal fate as a psychiatric patient, also reflects the tragic evolution of German psychiatric practices from the 1920s to the early 1940s, from strategies of empowerment to planned extermination.

After leaving the Schwetz hospital in late 1919, Goesch was institutionalized at a psychiatric hospital in Göttingen[28] in July 1921, where he remained with only short interruptions until 1934. His prolific artistic production attracted the attention of the psychiatrist Ernst Maschmeyer (1886–1936). Maschmeyer's comprehensive notes from the year 1925, preserved as part of Goesch's medical file, offer a lively portrait of the artist at work: passing remarks by Goesch and other behavioral traits, mentioned as potential elements toward a medical diagnosis, are interspersed with considerations about his technique as a draftsmen and thorough accounts of works in progress.[29]

Maschmeyer's notes on Goesch are largely influenced by the tenets of the "Heidelberg school of psychiatry,"[30] which entails an emphasis on patients' "self-descriptions" (*Selbstschilderungen*), thoroughly recorded in the medical file; a rejection of nosography—i.e., systematic descriptions of diseases—in favor of individualized case studies; and an over-reliance on the diagnostic category of schizophrenia or "dementia praecox."[31] These notes formed the basis for Maschmeyer's essay "A Contribution on the Art of Schizophrenics," published in 1926 (fig. 17).[32] While refraining from establishing a systematic link between mental health diagnoses and specific elements in visual compositions by patients—along the lines of Prinzhorn's theories, quoted by Maschmeyer on

multiple occasions[33]—Maschmeyer offered a pathologizing reading of Goesch, ascribing his creativity solely to mental health issues[34] while minimizing his membership in professional artistic circles.

In 1934, Goesch was relocated to a psychiatric hospital in Teupitz, near Berlin, which resulted in a marked deterioration of his living conditions. He was not allowed to draw or paint and seems to have been relatively neglected, as attested by the laconic annotations in his administrative file.[35] Goesch's diagnosis of incurable schizophrenia and the exceptionally high percentage of Nazi party members among the medical staff at Teupitz[36] put him in a particularly vulnerable position as Nazi authorities implemented the campaign of planned mass murders of patients in psychiatric institutions known as Aktion T4. Goesch was murdered in a gas chamber in Brandenburg an der Havel on August 20, 1940.

Goesch's work was also the target of the Nazi regime's smear campaign against members of the avant-garde. A reproduction of a mural by him was featured in a pamphlet by Wolfgang Willrich bearing the threatening title *Cleanup of the Temple of Art: An Art-Political Pamphlet for the Recovery of German Art in the Nordic Spirit*, alongside works by fellow members of the November Group Hannah Höch and Otto Freundlich, as part of a charge against what the Nazis deemed to be "cultural bolshevism" (fig. 18).[37]

While Willrich's attack, as well as the confiscation of Goesch's art from the collection of the Kunsthalle Mannheim in 1937, targeted him as a member of the avant-garde,[38] his work was also featured in the Berlin and Leipzig iterations of the traveling *Entartete Kunst* (*Degenerate Art*) exhibition in 1938 as part of a loan of one hundred works from the collection of the Heidelberg psychiatric clinic. In these exhibitions, works of "pathological art" were displayed alongside

28. Founded in the second half of the nineteenth century by psychiatry reformer Ludwig Meyer—a figure comparable to Philippe Pinel, famously discussed in Michel Foucault's *History of Madness*—Göttingen hospital had pioneered the introduction of more humane methods in patient care, including the abandonment of restraints, and was one of the earliest research hospitals.
29. Excerpts from these notes, which have only been partially preserved, are reproduced in Röske, ed., *Paul Goesch, 1885–1940*, 178–89.
30. On the main features of the Heidelberg school, see Werner Janzarik, "Jaspers, Kurt Schneider and the Heidelberg School of Psychiatry," *History of Psychiatry* 9 (1998): 241–52. On the relation among case studies, art, and the diagnostic category of schizophrenia in the work of the Heidelberg school, see Doris Kaufmann, "Kunst, Psychiatrie und 'Schizophrenes Weltgefühl'," in *Kunst und Krankheit. Studien zur Pathographie*, ed. Matthias Bormuth (Göttingen, Germany: Wallstein, 2003), 57–72.
31. Goesch's diagnosis first appeared in his medical file at Göttingen as "dementia praecox" in 1922; it was then logged as "schizophrenia" the following year, with no further comment to the evolution of the diagnosis, which seems to indicate the relative porosity of these diagnostic categories. On this point, see Maike Rotzoll, "Endstation Brandenburg. Paul Goesch und der nationalsozialistische Krankenmord," in Patricia Feise-Mahnkopp and Thomas Röske, *"Von zweifellos künstlerischem Wert"*:

Paul Goeschs Beitrag zur ästhetischen Moderne (Heidelberg: Sammlung Prinzhorn; Berlin: Kerber Verlag, 2019), 25.
32. Ernst Maschmeyer, "Ein Beitrag zur Kunst der Schizophrenen," *Archiv für Psychiatrie und Nervenkrankheiten* 78 (1926): 510–21. The second half of the essay (pages 516–21) is entirely dedicated to Goesch.
33. Röske, "Paul Goesch – zwischen Avantgarde und Anstalt," 26.
34. Maschmeyer, "Ein Beitrag zur Kunst der Schizophrenen," 517.
35. See Rotzoll, "Endstation Brandenburg," 25.
36. In 1945, 70 percent of the staff were members of the Nazi party, an exceptionally high percentage in the region. See Wolfgang Rose, "Brüche und Kontinuitäten. Die Landesanstalt 1945-1964," in *Landesklinik Teupitz. Geschichte-Architektur-Perspektiven* (Berlin: Berlin-Brandenburg, 2003), 87.
37. Wolfgang Willrich, *Säuberung des Kunsttempels: eine kunstpolitische Kampfschrift zur Gesundung deutscher Kunst im Geiste nordischer Art* (Munich: Lehmann, 1937).
38. These works might also have been displayed in the *Entartete Kunst* exhibition (Röske, "Paul Goesch – zwischen Avantgarde und Anstalt," in Röske, ed., *Paul Goesch, 1885–1940*, 26), in which case Goesch would have been the only artist to be featured in both groups of works in these exhibitions, i.e., as a member of the avant-garde and as an example of "pathological art."

avant-garde art as comparative materials, supposedly to "prove" their pathological character. Goesch was possibly the only artist whose work was displayed in both groups, reflecting the incoherent nature of the *Degenerate Art* exhibition, as well as the fact that Nazi repression tragically mirrored the dual reception of Goesch's work, targeting him as both a psychiatric patient and a card-carrying member of the interwar avant-garde.

Only a few years after his death, works by Goesch preserved as part of his medical file at Göttingen were reproduced and discussed in medical monographs by psychiatrists Gottfried Ewald and Hemmo Müller-Suur.[39] Unlike Maschmeyer's firsthand account, these anonymized case studies did not focus on Goesch's personal trajectory, but rather on the way in which his works might support theoretical elaborations on schizophrenia. For that purpose, the psychiatrists did not hesitate to distort biographical facts as they might have been handed down in Goesch's file. In 1944, Ewald described Goesch's works as examples of dementia "based on muddled compositional principles."[40] Conversely, in four monographs published in 1948, 1953, 1966, and 1967, Müller-Suur asserted that Goesch's works, such as his abstract *Composition in Red* (fig. 19), which was reproduced in the psychiatrist's 1948 monograph, should not be perceived as the result of "muddling," but were rather "preserving of meaning" (*sinnerhaltend*) as a form of resistance against the progressive dissolution of the personality. However, according to him, they also bore traces of pathological phenomena, such as hallucinatory experiences.

If Müller-Suur's evaluation was diametrically opposed to Ewald's, both authors described Goesch's work as patient art that pointed to a specific type of diagnosis, entirely disregarding his activities as a professional artist. Goesch's presence in postwar psychiatric discourses was thus based on a process of pathologization that implied the erasure of crucial aspects of his work and identity.

GOESCH TODAY

Studying the reception of Paul Goesch amounts to entering a strange hall of mirrors, in which visibility is achieved at the price of heavy distortions, slippages, and disfigurements, and in which often incompatible discourses inexplicably alternate, at times sidelining or purposefully obscuring the work altogether in favor of examples that might more aptly support preexisting assumptions and arbitrarily defined labels.

39. On the discussions of Goesch's work by Ewald and Müller-Suur, I am indebted to the excellent study by Annabel Ruckdeschel, "'Schizophrene Kunst' und Abstraktion. Paul Goeschs Kunstwerke in den psychiatrischen Texten Hemmo Müller-Suurs und ihre Pathologisierung nach 1945," in *"Von zweifellos künstlerischem Wert": Paul Goeschs Beitrag zur ästhetischen Moderne*, ed. Patricia Feise-Mahnkopp and Thomas Röske (Bielefeld and Berlin: Kerber Verlag, 2019), 58–73.

40. Gottfried Ewald, *Lehrbuch der Neurologie und Psychiatrie* (Munich and Berlin: Urban & Schwarzenberg, 1944), 377; also quoted and discussed in Ruckdeschel, "'Schizophrene Kunst' und Abstraktion," 60.

Abb. 23. Novembergruppe (Gefolgſchaft).

1. Hanna Hoech: Journaliſten, 1925. – 2. Walter Kampmann: Diana im Waſſer ſtehend und ſchießend, 1930. – 3. ? Abſtrakte Konſtruktion, 1926. – 4. Annelieſe Ratkowſki Braun: Das Grauen, 1925. 5. Walter Kampmann: Dem Frühling entgegen, 1923, mit Jalouſierahmen. – 6. Heinrich Campen=donk: Orientaliſches. – 7. Otto Freundlich: Kopf. – 8. Nikolaus Braun: Dämon. – 9. Paul Goeſch: Wandmalerei. – 10. Karl Völker: Zwei Kinder

Fig. 18. Wolfgang Willrich, *Säuberung des Kunsttempels: eine kunstpolitische Kampfschrift zur Gesundung deutscher Kunst im Geiste nordischer Art* (*Cleanup of the Temple of Art: An Art-Political Pamphlet for the Recovery of German Art in the Nordic Spirit*) (Berlin: JF Lehmanns Verlag, 1937), 54.

While Prinzhorn would fall squarely in the latter group, as Goesch's professional artistic career did not pass muster with his outlandish theories on free will and spontaneity, another aspect of Prinzhorn's writings could aptly be applied to Goesch: the idea that some works might be particularly able to challenge accepted viewing habits and lead one to question normative systems of reception and evaluation.[41]

However, it is equally important to note that the "boundary breaking" potential of Goesch's work had in fact very little to do with any deliberate decision by their author, or with the work itself.[42] While Goesch's reception is mostly structured around diametrically opposed discourses—"naive" and "savant," isolation and interconnectedness, art historical accounts of the interwar avant-garde and pathologizing views on patient art—his work displayed a remarkable coherence over more than two decades, and across various media, and his theoretical writings offered valuable insights into his visual works. There is, for instance, no thematic or stylistic feature that might allow one to distinguish between works produced by Goesch in or outside of psychiatric institutions, that is, works that might have been labeled "avant-garde" or "patient art," purely on the basis of their respective modes of production.

In this context, the practice of reception studies becomes an exercise in interpretative humility: becoming conscious of the ideological projections that led to the total or partial erasure of Goesch's work should encourage scholars and viewers to question their own assumptions and critical tools, so as not to repeat the same mistakes and distortions—and to attempt to gain a better appreciation of his works, instead of using them as mere illustrations for often unrelated theories.

In 2016, Paul Goesch was featured in two major exhibitions in Germany: alongside his avant-garde colleagues Paul Scheerbart and Bruno Taut in *Modern Visionaries* (*Visionäre der Moderne*) at the Berlinische Galerie in Berlin, and in the exhibition *Paul Goesch—Between Avant-garde and Asylum* (*Paul Goesch—zwischen Avantgarde und Anstalt*) at the Sammlung Prinzhorn in Heidelberg. To a certain extent, this institutional geography still reflects the dual nature of Goesch's reception as delineated in this essay. However, each exhibition was mindful of the complex reception history of the work and included studies on this subject in their respective catalogues.[43] After nearly a century, the evolution of critical discourses, historiography, and viewing habits might allow for a richer and more respectful kind of visibility for the work of Paul Goesch, one that would refrain from using it as a surface for ideological projections and would instead see it as an invaluable contribution in its own right.

41. Prinzhorn, *Bildnerei der Geisteskranken*, 7–8.

42. On this point, I would agree with Eberhard Roters's opposition between the vagaries of Goesch's reception and his tragic personal fate, on the one hand, and the consistency of Goesch's artistic production on the other. See Eberhard Roters, "Paul Goesch," in *Paul Goesch – Aquarelle und Zeichnungen*, 6.

43. See, for instance, Annelie Lütgens, "Die Rezeption Paul Goeschs durch Adolf Behne und Paul Westheim: Einleitung zum Wiederabdruck", in Lütgens, ed., *Modern Visionaries*, 121–25.

Fig. 19. Paul Goesch, *Composition in Red*, December 7, 1920. Gouache with partial coarse pigment and silver oxide over pencil, black chalk, and pen on laid paper, 8 1/8 x 9 in. (20.7 x 22.8 cm). © Prinzhorn Collection, University Hospital Heidelberg, no. 1090/92.

Plates

The works in this section are reproduced to approximate their
relative scale and are, in most cases, close to actual size.

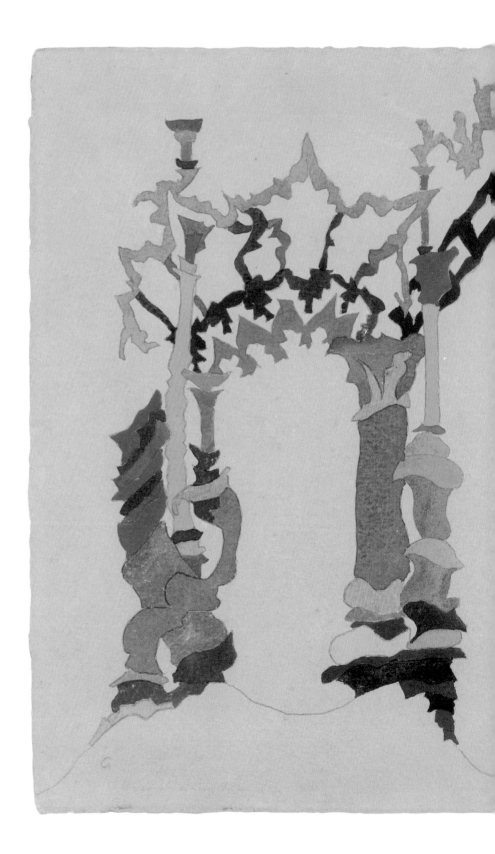

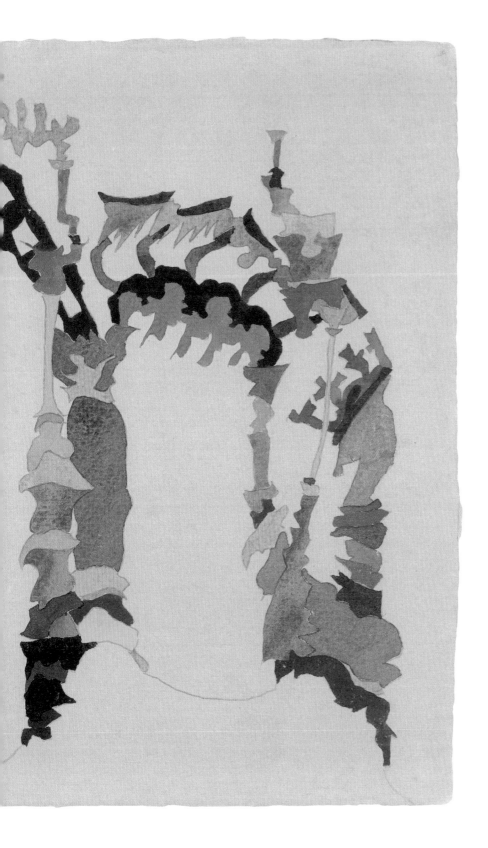

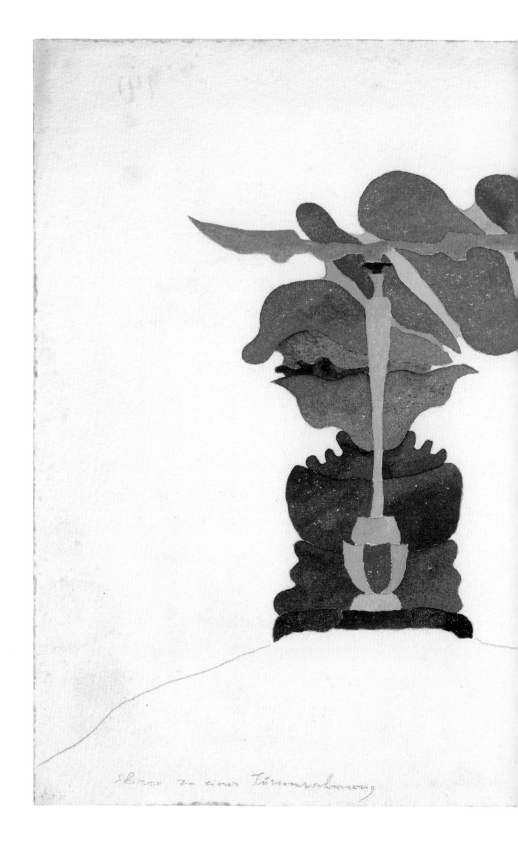

Skizze zu einer Türumrahmung

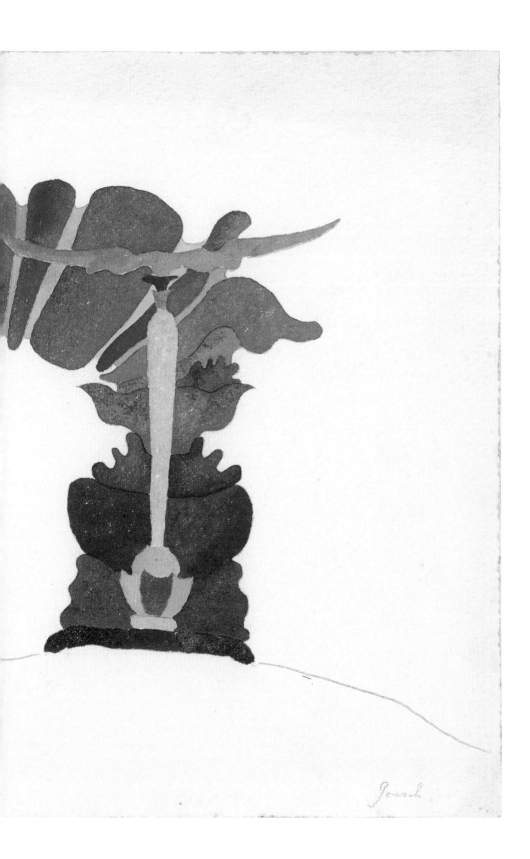

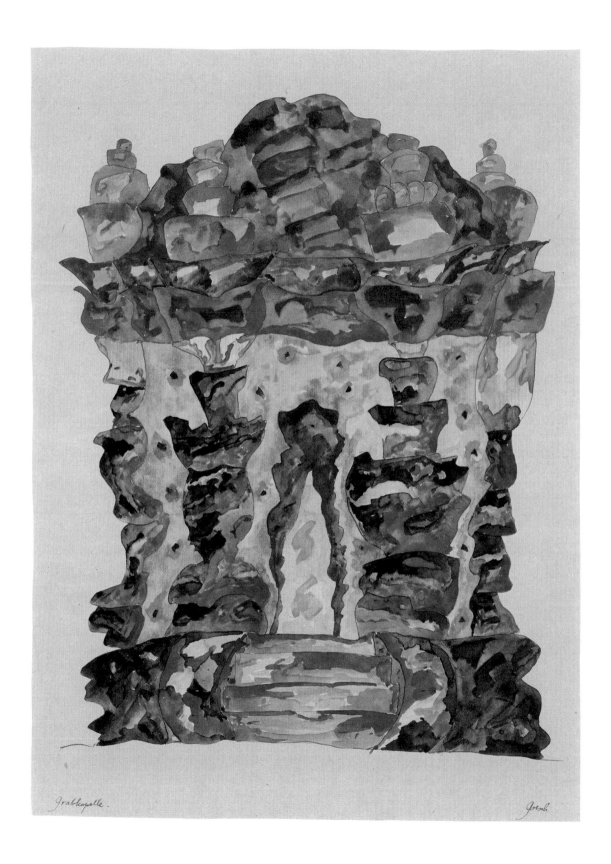

Grabkapelle. Goenh.

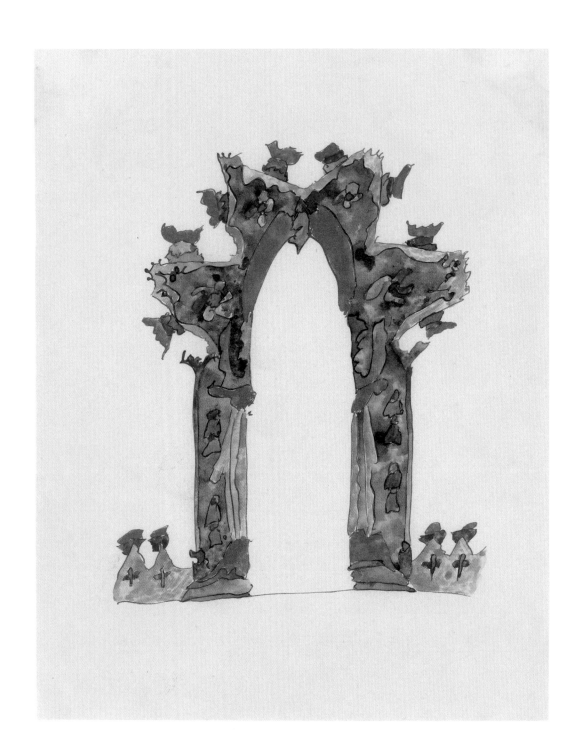

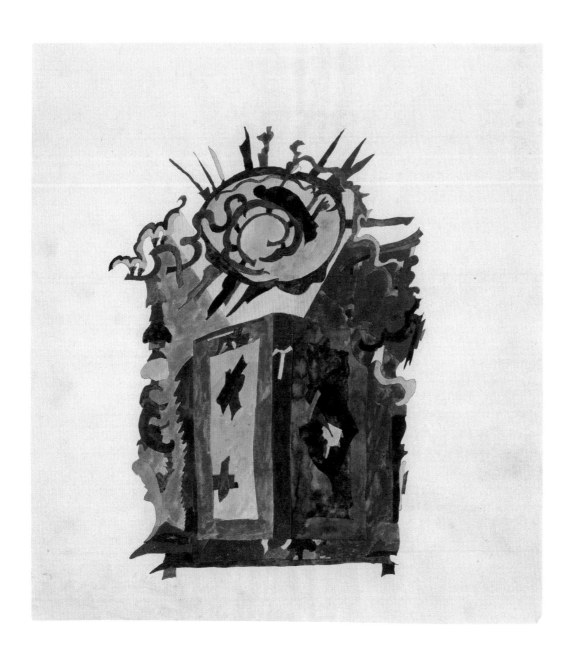

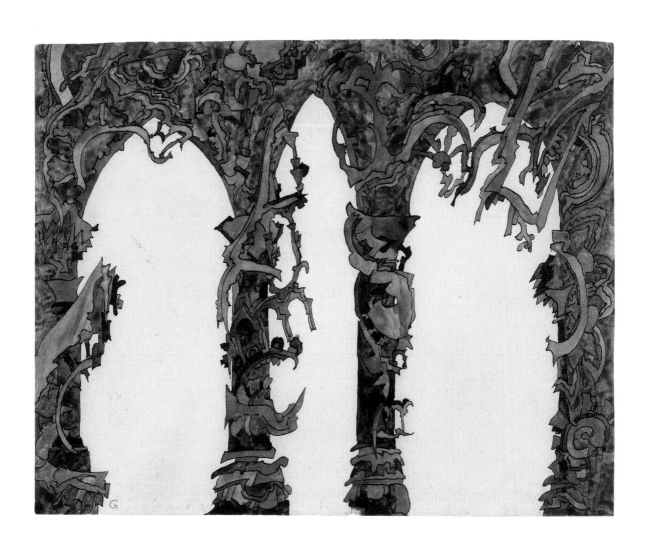

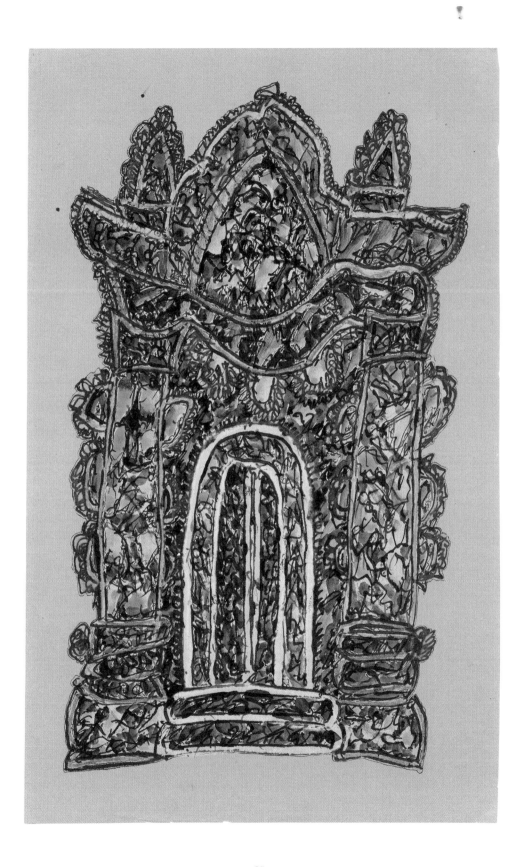

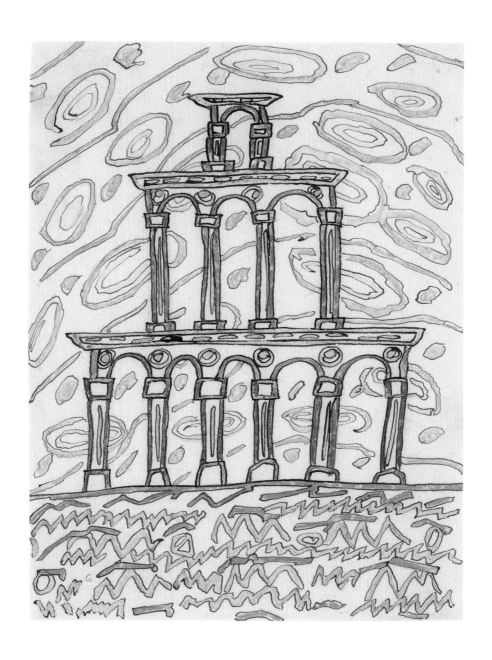

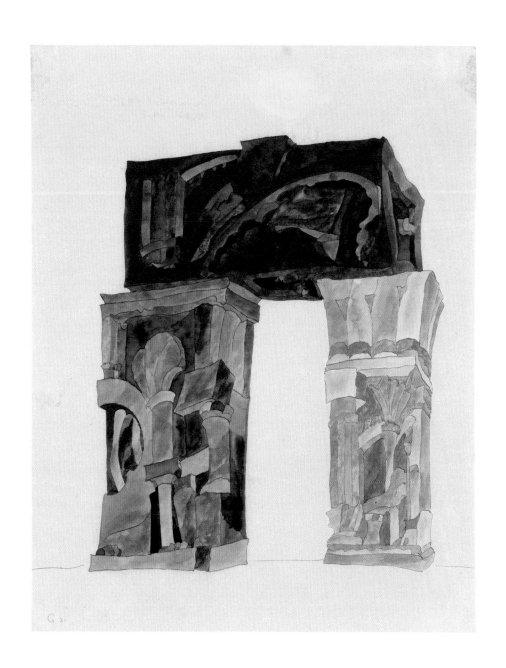

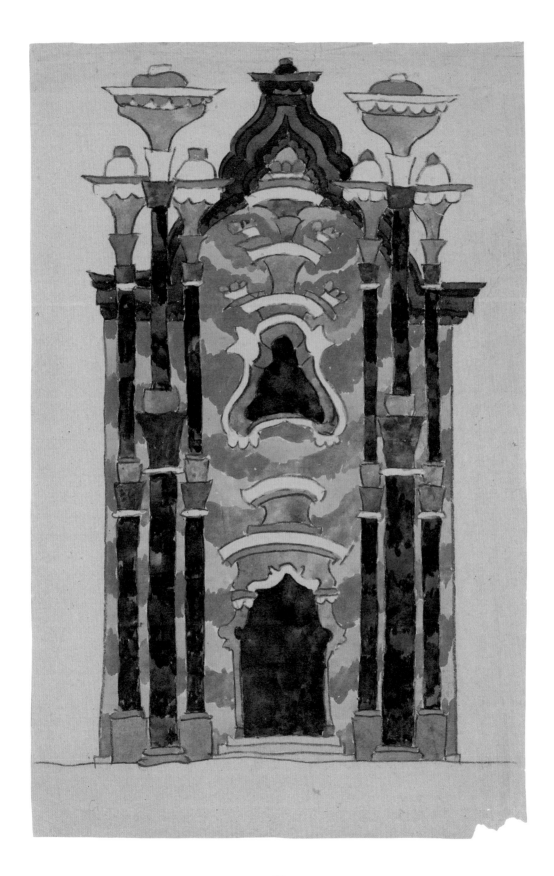

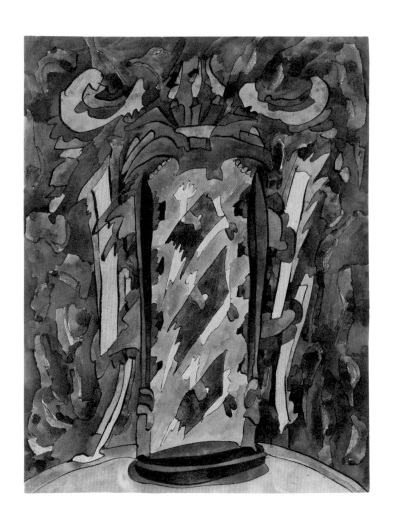

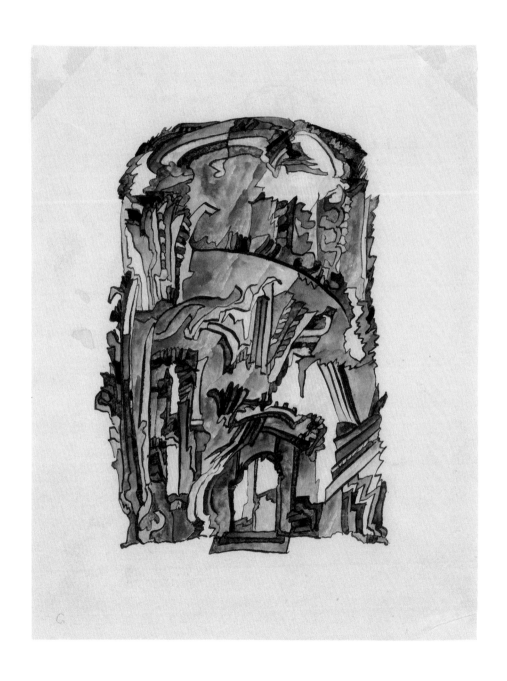

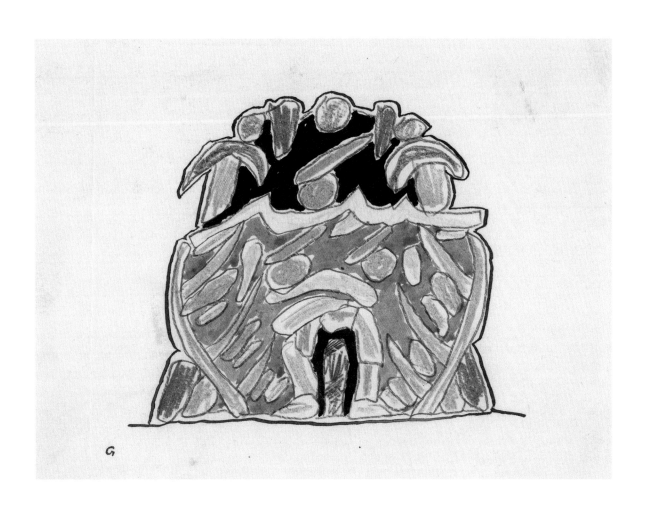

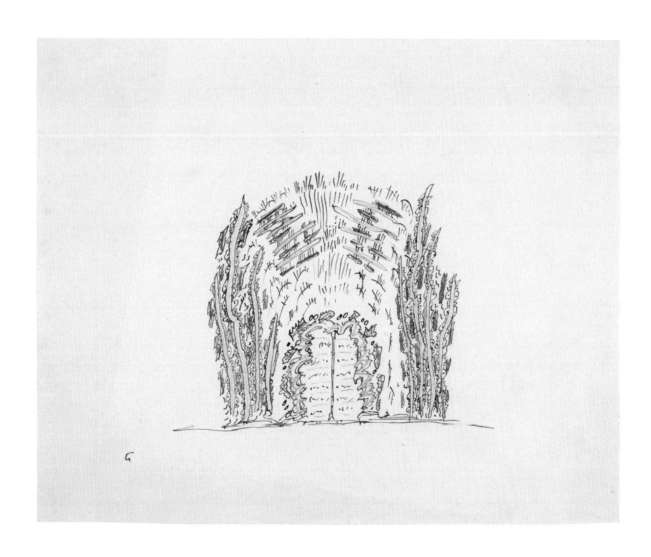

G

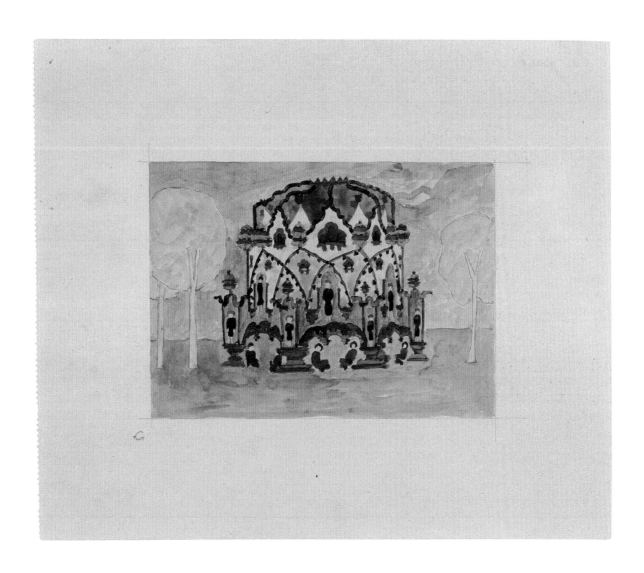

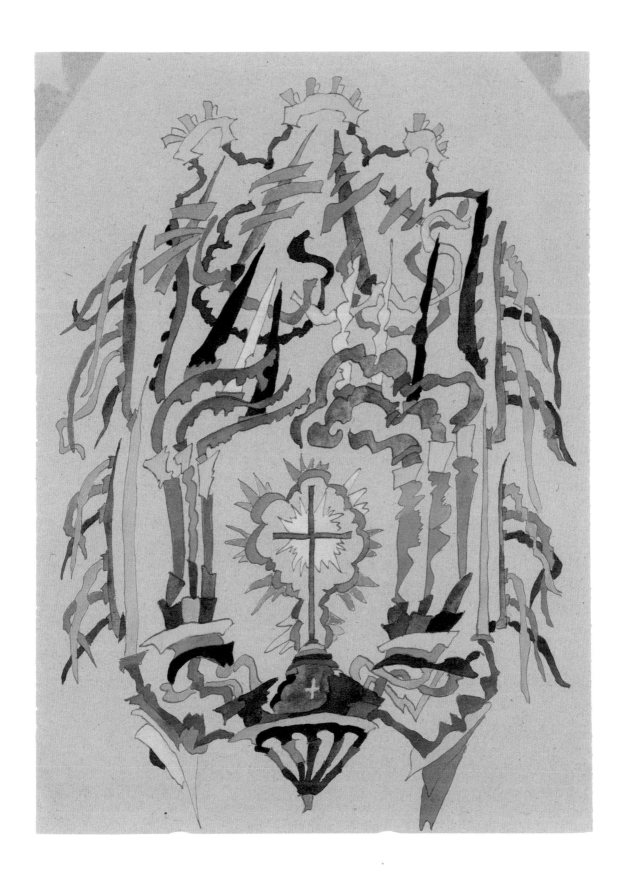

71

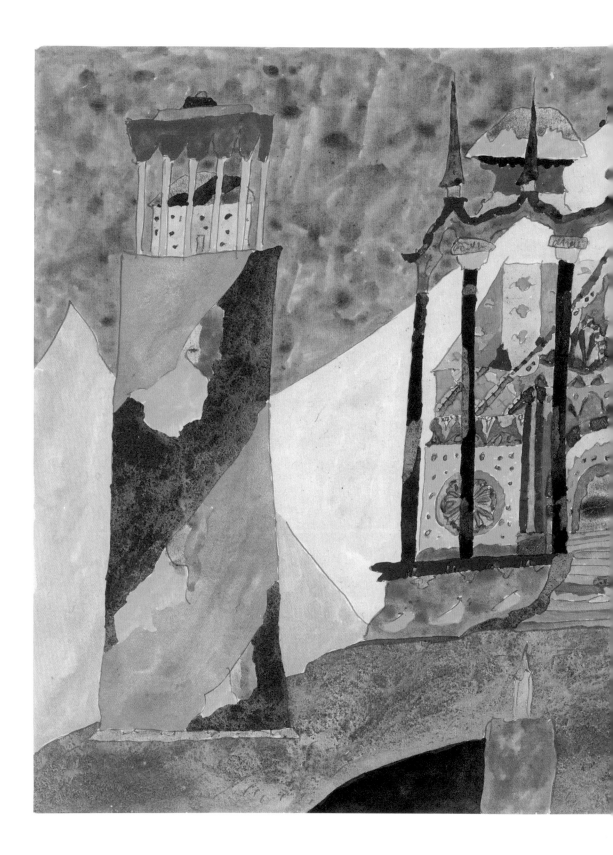

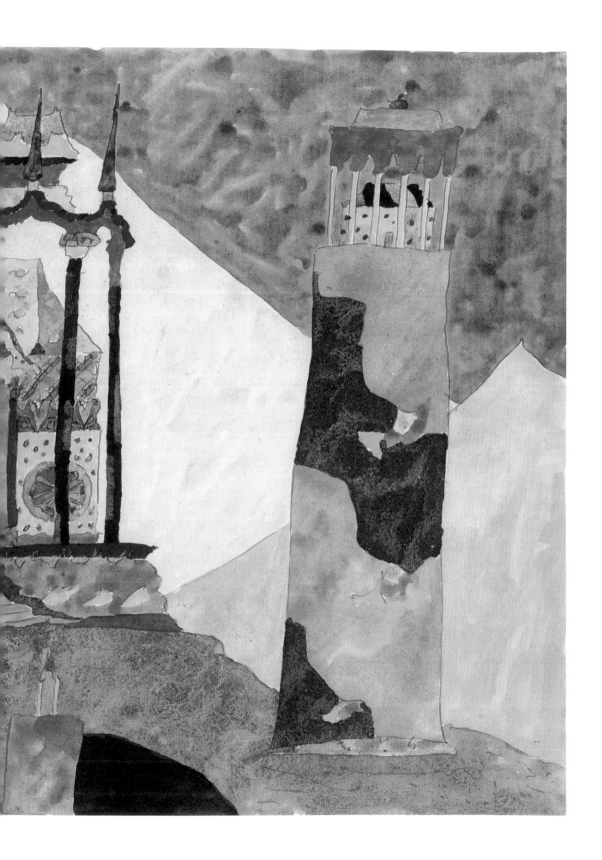

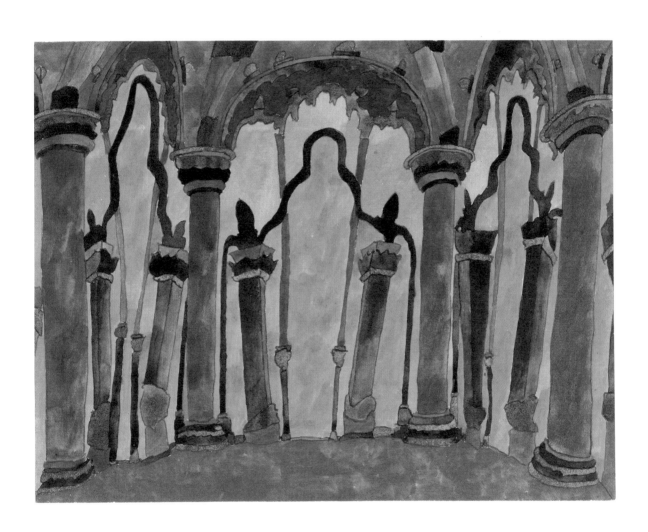

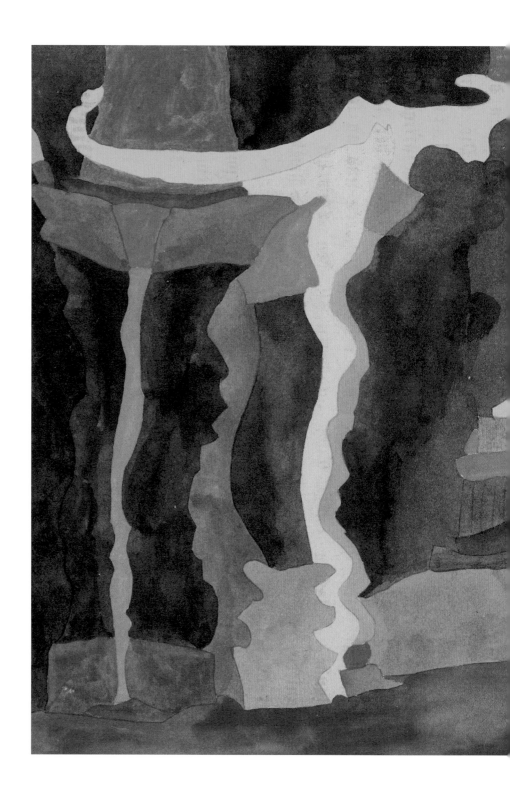

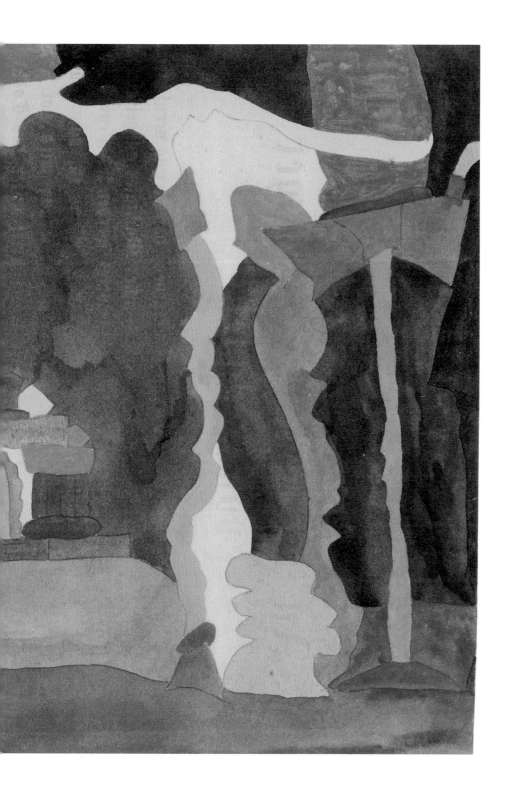

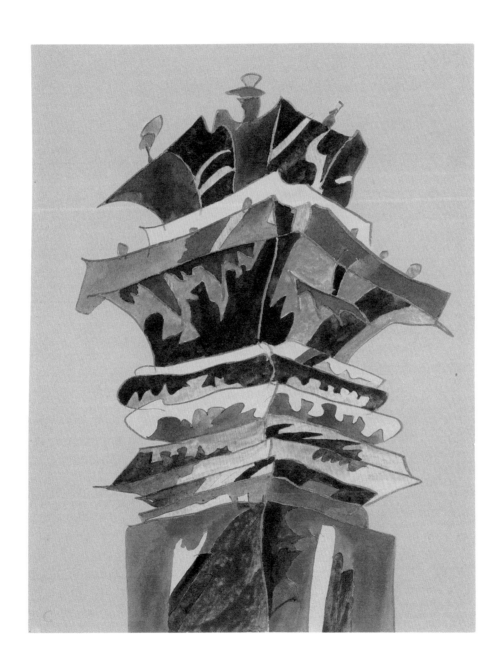

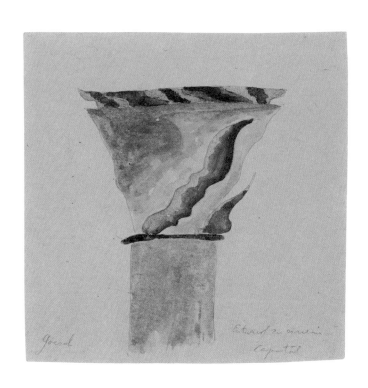

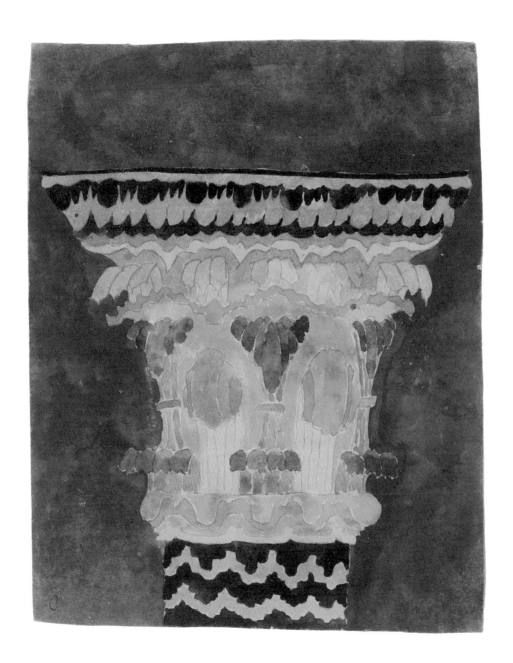

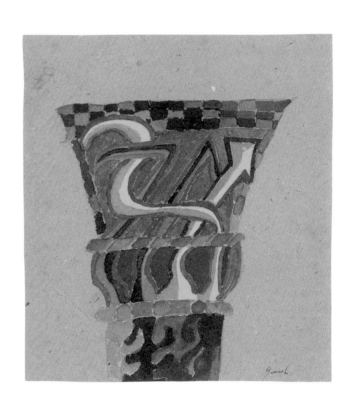

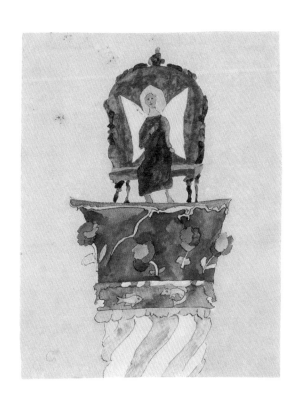

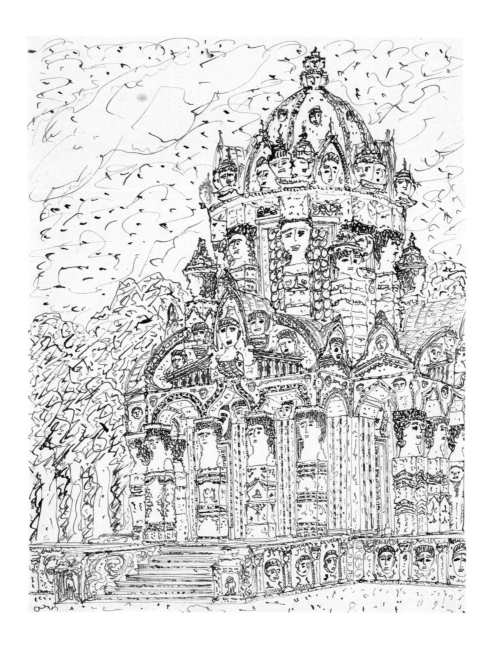

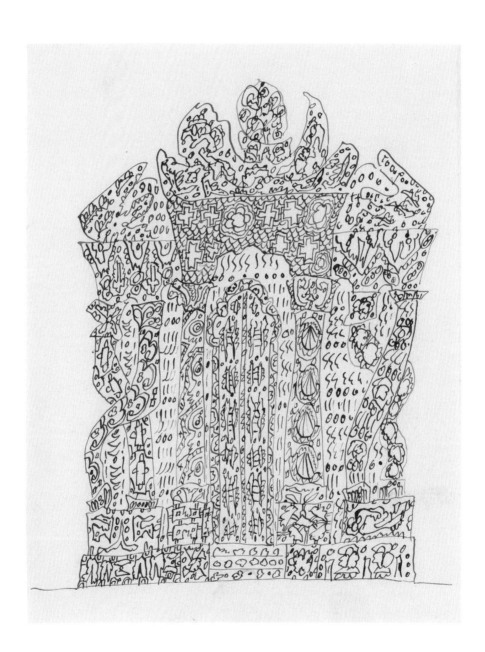

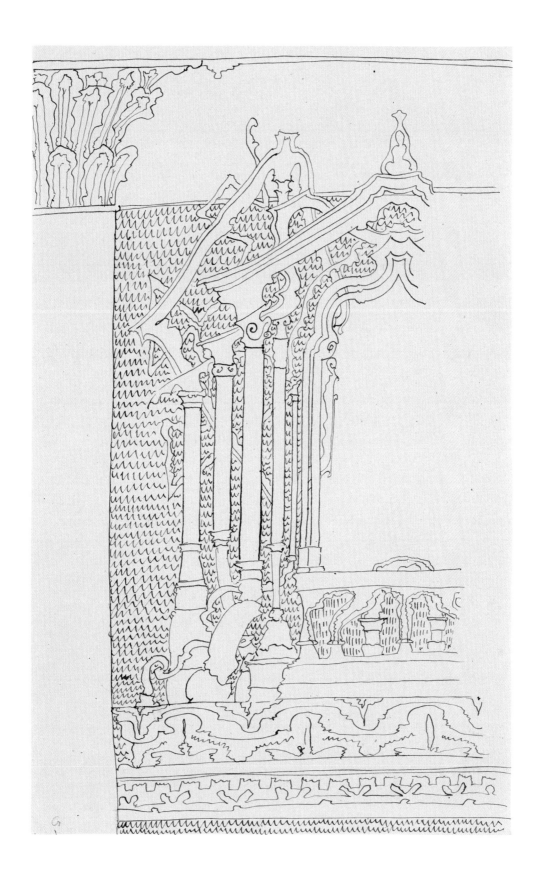

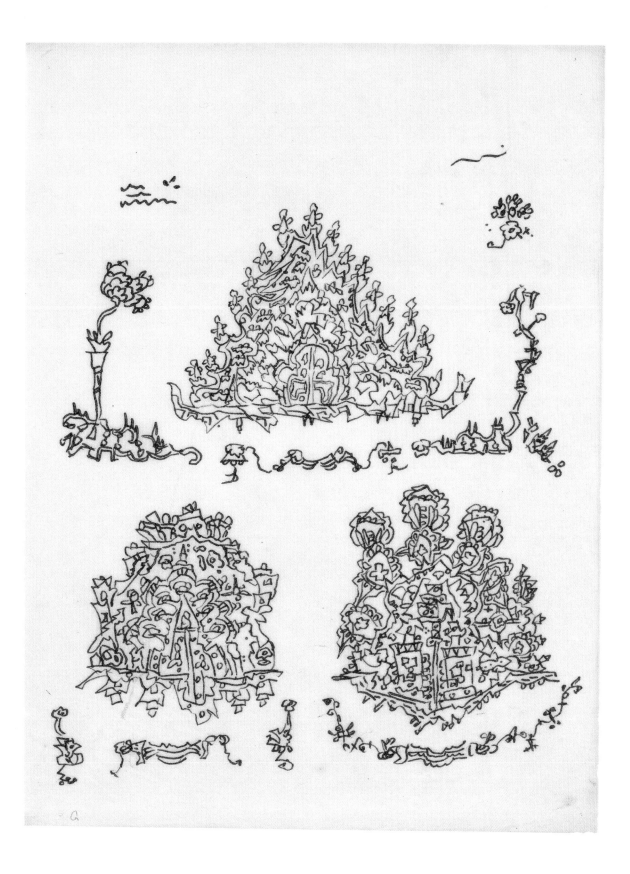

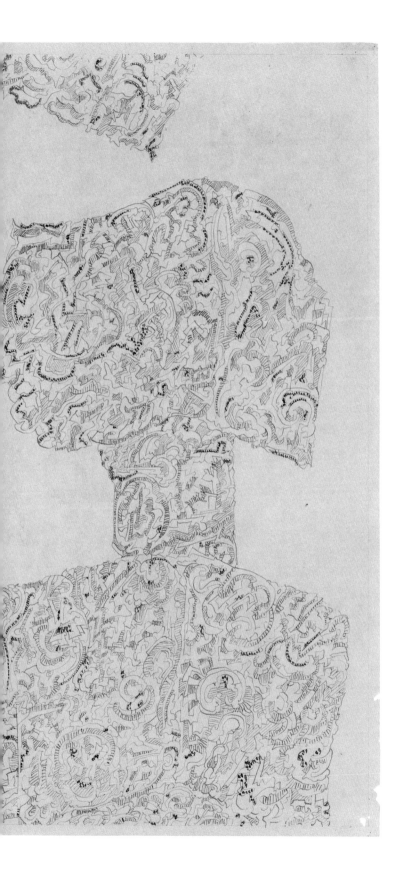

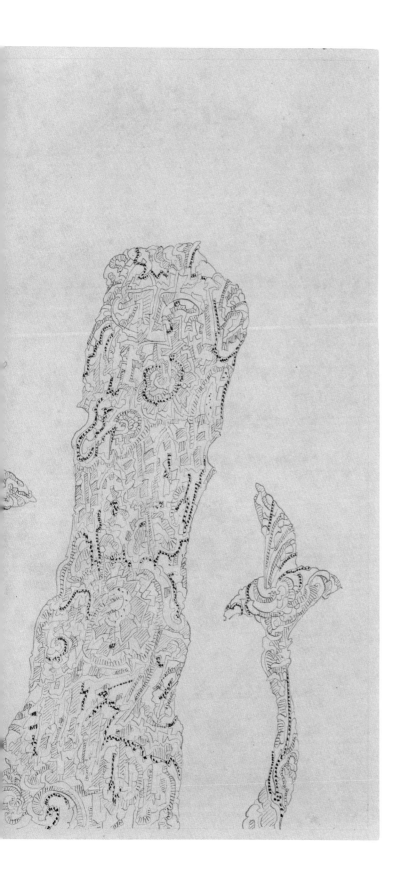

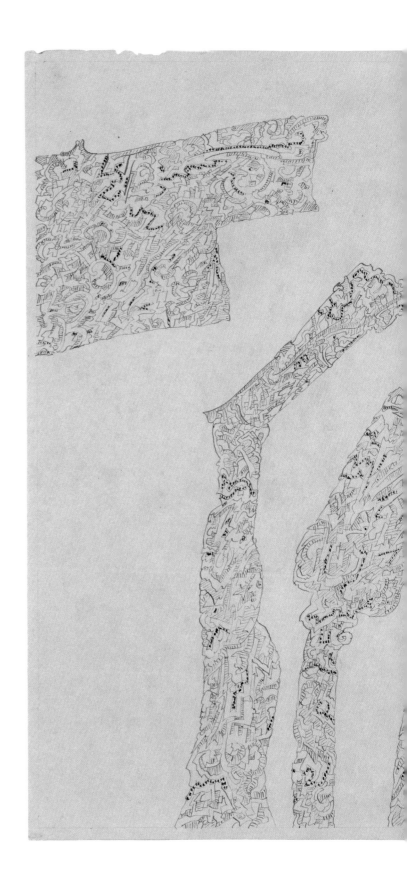

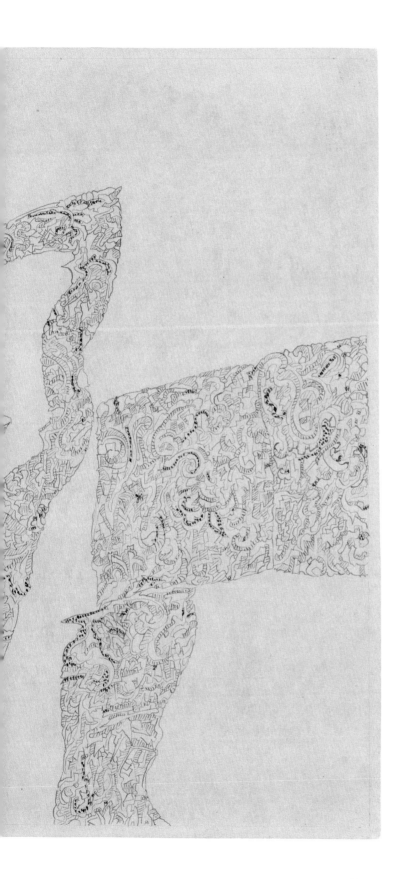

Checklist

Works by Paul Goesch (German, 1885–1940)
Centre Canadien d'Architecture/Canadian Centre for Architecture, Montreal

pp. 44–45 *Architectural composition (Triumphal arch)*
or *Visionary design for a gateway*
c. 1920–21
Graphite and gouache on watercolor
paper
9 1/2 x 12 5/8 in. (24.2 x 32 cm)
DR1988:0241

pp. 46–47 *Visionary design for an arch*
c. 1920–21
Graphite and gouache
10 7/16 x 14 13/16 in. (26.5 x 37.6 cm)
DR1988:0254

p. 49 *Visionary design for the facade
of a chapel*
c. 1920–21
Pen and black ink, watercolor, and
gouache
11 5/16 x 8 1/4 in. (28.8 x 21 cm)
DR1988:0108

p. 50 *Visionary design for a gateway*
c. 1920–21
Pen and black ink, watercolor, and
gouache
8 13/16 x 6 15/16 in. (22.4 x 17.7 cm)
DR1988:0243

p. 51 *Architectural fantasy*
c. 1920–21
Gouache over pen and black ink
8 7/8 x 8 3/16 in. (22.6 x 20.8 cm)
DR1988:0058

p. 53 *Architectural composition (Triumphal arch)*
1921
Pen and black ink and gouache on wove
paper
6 7/16 x 8 1/4 in. (16.4 x 20.9 cm)
DR1988:0240

p. 55 *Visionary design for a multicolored portico*
c. 1920–21
Pen and black ink, watercolor, and pastel
12 15/16 x 8 1/4 in. (32.9 x 20.9 cm)
DR1988:0134

p. 56 *Architectural pyramid* or *Design for a
three-level arcade shaped like a pyramid*
c. 1920–21
Pastel over pen and black ink
8 1/4 x 6 7/16 in. (20.9 x 16.3 cm)
DR1988:0066

p. 57 *Architectural composition (Triumphal arch)*
or *Visionary design for a freestanding
gateway*
1921
Watercolor and gouache over pen and
black ink on tracing paper
8 3/16 x 6 7/16 in. (20.8 x 16.3 cm)
DR1988:0242

p. 59 *Visionary design for a facade, possibly
of a chapel*
c. 1920–21
Black pencil, watercolor, and gouache
18 1/2 x 12 in. (47 x 30.5 cm)
DR1988:0238

p. 60 *Architectural fantasy*
January 1, 1921
Gouache, watercolor, and blue ink
over pen and black ink, with silver and
bronze-colored pigment
8 3/16 x 6 1/2 in. (20.8 x 16.5 cm)
DR1988:0057

p. 61 *Architectural fantasy*
Probably March 19, 1921
Pen and black ink, watercolor, and
gouache
8 1/4 x 6 7/16 in. (20.9 x 16.3 cm)
DR1988:0244

p. 63 *Architectural composition (facade)* or
Visionary design for the facade of a building
c. 1920–21
Graphite and pen and black ink, with
colored gouache and colored pencil on
wove paper
7 x 8 13/16 in. (17.8 x 22.4 cm)
DR1988:0091

p. 65 *Visionary design for the facade
of a building*
c. 1920–21
Pen and black ink with blue, green, and
orange pencil
7 x 8 3/4 in. (17.8 x 22.3 cm)
DR1988:0097

p. 67 *Visionary design for a round temple*
c. 1920–21
Watercolor and gouache over graphite
6 3/8 x 7 5/8 in. (16.2 x 19.3 cm)
DR1988:0077

Other works in the exhibition

Erich Heckel
German, 1883–1970
Portrait of a Man
1918
Color woodcut, over zincograph, in green,
blue, ochre, and black on paper
18 3/16 x 12 7/8 in. (46.2 x 32.7 cm)
Clark Art Institute, Williamstown,
Massachusetts
2012.7

Lyonel Feininger
American, 1871–1956
Gelmeroda
1920
Woodcut (re-strike) on Sekishu
Natural Japanese handmade paper
by Spiral Press, N.Y.
15 15/16 x 12 in. (40.5 x 30.5 cm)
Clark Art Institute, Williamstown,
Massachusetts
Gift of the estate of William J. Collins
1982.111

Max Beckmann
German, 1884–1950
Cafe Music (*Cafemusik*), from
Faces (*Gesichter*)
1918
Drypoint
12 x 9 in. (30.5 x 22.9 cm)
Williams College Museum of Art,
Williamstown, Massachusetts
Gift of the Estate of June B. Pinsof
M.2013.10.20

Max Pechstein
German, 1881–1955
But deliver us from evil (*Sondern erlöse uns
von dem Übel*) from *The Lord's
Prayer* (*Das Vater Unser*)
1921
Woodblock on paper with
hand-coloring
19 3/16 x 14 7/16 in.
(48 3/4 x 36 5/8 cm)
Williams College Museum of Art,
Williamstown, Massachusetts
Gift of Madeleine P. and Harvey R.
Plonsker, Class of 1961
M.2015.25.21

Käthe Kollwitz
German, 1867–1945
Memorial sheet for Karl Liebknecht
1920
Woodcut on paper
15 7/8 x 21 15/16 in. (40.4 x 55.7 cm)
Clark Art Institute, Williamstown,
Massachusetts
2010.1

Wassily Kandinsky
Russian, 1866–1944
Untitled
1924
Drypoint
11 1/4 x 10 1/4 in. (28.6 x 26 cm)
Williams College Museum of Art,
Williamstown, Massachusetts
Gift of Madeleine P. and Harvey R.
Plonsker, Class of 1961
M.2016.26.27

Hermann Finsterlin
German, 1887–1973
Formal study
1920
Graphite and watercolor, with some
gouache
11 x 13 7/8 in. (28 x 35.2 cm)
Centre Canadien d'Architecture/Canadian
Centre for Architecture, Montreal
DR1988:0260

Hermann Finsterlin
German, 1887–1973
Study for a building, series X, no. 7
c. 1922
Pen and red and black ink, black wash,
white gouache, and traces of graphite
4 15/16 x 8 9/16 in. (12.6 x 21.7 cm)
Centre Canadien d'Architecture/Canadian
Centre for Architecture, Montreal
DR1988:0267

Hermann Finsterlin
German, 1887–1973
Study for a hall, series X, no. 7
c. 1922
Pen and black ink and white gouache, over
graphite
5 3/8 x 8 9/16 in. (13.6 x 21.8 cm)
Centre Canadien d'Architecture/Canadian
Centre for Architecture, Montreal
DR1988:0266

Hermann Finsterlin
German, 1887–1973
Ground plan, series III, no. 7
c. 1922
Pen and black ink and brush and black ink,
over graphite
7 11/16 x 10 5/16 in. (19.5 x 26.2 cm)
Centre Canadien d'Architecture/Canadian
Centre for Architecture, Montreal
DR1988:0264

Hermann Finsterlin
German, 1887–1973
Ground plan, series III, no. 7
c. 1922
Pen and black, red, and blue ink, over
graphite
7 1/8 x 10 5/16 in. (18.1 x 26.2 cm)
Centre Canadien d'Architecture/Canadian
Centre for Architecture, Montreal
DR1988:0263

Bruno Taut
German, 1880–1938
*Illustrated letter with a drawing of a project
for the monument to the dead*
December 23, 1919
Reprographic copy on paper
13 7/16 x 9 1/16 in. (34.2 x 23 cm)
Centre Canadien d'Architecture/Canadian
Centre for Architecture, Montreal
DR1988:0023:003

Bruno Taut
German, 1880–1938
Drawings for the Crystal House Project
c. 1919–20
Reprographic copy on paper
11 3/4 x 16 9/16 in. (29.8 x 42 cm)
Centre Canadien d'Architecture/Canadian
Centre for Architecture, Montreal
DR1988:0023:017

Artist unknown
*Rear view, Glass Pavilion, Deutscher
Werkbund Ausstellung, Cologne, Germany*
Between 1914 and 1916
Gelatin silver print
9 x 6 5/8 in. (22.9 x 16.9 cm)
Centre Canadien d'Architecture/Canadian
Centre for Architecture, Montreal
PH1987:0178

Artist unknown
*View of spiral staircase, Glass Pavilion,
Deutscher Werkbund Ausstellung, Cologne,
Germany*
Between 1914 and 1916
Gelatin silver print
8 7/8 x 6 9/16 in. (22.5 x 16.6 cm)
Centre Canadien d'Architecture/Canadian
Centre for Architecture, Montreal
PH1982:0245

Georg Biermann, ed.,
*Der Cicerone: Halbmonatsschrift für
Künstler, Kunstfreunde, und Sammler*
vol. 12, no. 4 (Leipzig: Verlag von Klinkhardt
& Biermann, February 1920)
Clark Art Institute Library,
Williamstown, Massachusetts

Bruno Taut, ed., *Frühlicht*, vol. 3
(Magdeburg: Karl Peters Verlag, 1922)
Clark Art Institute Library,
Williamstown, Massachusetts

Further Reading

PAUL GOESCH

Amann, Claudia, Dietrich Arlt, and Janni Müller-Hauck. *Paul Goesch, 1885–1940: Aquarelle und Zeichnungen*. Berlin: Berlinische Galerie, 1976.

Feise-Mahnkopp, Patricia and Thomas Röske, eds. *"Von zweifellos künstlerischem Wert": Paul Goeschs Beitrag zur ästhetischen Moderne*. Heidelberg: Sammlung Prinzhorn; Berlin: Kerber Verlag, 2019.

Lütgens, Annelie, ed. *Visionäre der Moderne: Paul Scheerbart, Bruno Taut, Paul Goesch / Modern Visionaries: Paul Scheerbart, Bruno Taut, Paul Goesch* (Berlin: Berlinische Galerie; Zurich: Scheidegger & Spiess, 2016).

Röske, Thomas and Prinzhorn-Sammlung der Psychiatrischen Universitätsklinik Heidelberg, eds. *Paul Goesch, 1885–1940: Zwischen Avantgarde und Anstalt*. Heidelberg: Wunderhorn, 2016.

EXPRESSIONIST ARCHITECTURE

Barnstone, Deborah Ascher. *The Break with the Past: Avant-Garde Architecture in Germany, 1910–1925*. New York: Routledge, 2018.

Beil, Ralf, and Claudia Dillmann, eds. *The Total Artwork in Expressionism: Art, Film, Literature, Theater, Dance, and Architecture, 1905–25*. Darmstadt, Germany: Institut Mathildenhöhe; Ostfildern, Germany: Hatje Cantz, 2011.

Benson, Timothy O., ed. *Expressionist Utopias: Paradise, Metropolis, Architectural Fantasy*. Berkeley: University of California Press; Los Angeles: Los Angeles County Museum of Art, 2001.

Boyd Whyte, Ian. *The Crystal Chain Letters Architectural Fantasies by Bruno Taut and His Circle*. Cambridge, MA: MIT Press, 1985.

McElheny, Josiah and Christine Burgin, eds. *Glass! Love!! Perpetual Motion!!!: A Paul Scheerbart Reader*. New York: Christine Burgin; Chicago: University of Chicago Press, 2014.

Pehnt, Wolfgang. *Expressionist Architecture*. New York: Thames & Hudson, 1979.

ART AND MENTAL HEALTH

Cabañas, Kaira M. *Learning from Madness: Brazilian Modernism and Global Contemporary Art*. Chicago: University of Chicago Press, 2018.

English, Charlie. *The Gallery of Miracles and Madness: Insanity, Modernism, and Hitler's War on Art*. New York: Random House, 2021.

Foster, Hal. *Prosthetic Gods*. Cambridge, MA: MIT Press, 2004.

Gilman, Sander L. *Seeing the Insane*. Lincoln, NE: University of Nebraska Press, 1996.

MacGregor, John M. *The Discovery of the Art of the Insane*. Princeton, NJ: Princeton University Press, 1989.

Santner, Eric L. *My Own Private Germany: Daniel Paul Schreber's Secret History of Modernity*. Princeton, NJ: Princeton University Press, 1996.

Tuchman, Maurice and Carol S. Eliel, eds. *Parallel Visions: Modern Artists and Outsider Art*. Los Angeles: Los Angeles County Museum of Art; Princeton, NJ: Princeton University Press, 1992.

Contributors

ROBERT WIESENBERGER is curator of contemporary projects at the Clark Art Institute and lecturer in the Williams Graduate Program in the History of Art.

RAPHAEL KOENIG is visiting assistant professor (ATER) in Comparative Literature at the University of Toulouse II, and associate researcher at the University of Toulouse II's Literature, Languages and Visual Arts Research Unit.